Teaching Art History with New Technologies

Teaching Art History with New Technologies: Reflections and Case Studies

Edited by

Kelly Donahue-Wallace, Laetitia La Follette and Andrea Pappas

Cambridge Scholars Publishing

Teaching Art History with New Technologies: Reflections and Case Studies,
Edited by Kelly Donahue-Wallace, Laetitia La Follette and Andrea Pappas

This book first published 2008 by

Cambridge Scholars Publishing

15 Angerton Gardens, Newcastle, NE5 2JA, UK

British Library Cataloguing in Publication Data
A catalogue record for this book is available from the British Library

ISBN (10): 1-84718-454-5, ISBN (13): 9781847184542

TABLE OF CONTENTS

LIST OF FIGURES

INTRODUCTION

KELLY DONAHUE-WALLACE, LAETITIA LA FOLLETTE, AND ANDREA PAPPAS

This book documents some of the changes that have occurred in the teaching of art history in the last decade. It provides both a history and an analysis of the increasing number of computer-based tools now at the disposal of art historians. It was prompted by the dearth not only of readily accessible information about teaching art history with new technologies,[1] but of pedagogical literature for art history in general.[2] Currently, there are few places where art historians can go for help in navigating the journey between traditional and computer-mediated practices in teaching. Thus a fair amount of trial-and-error experimentation is being replicated over and over again at colleges and universities. For faculty to succeed with the new applications and approaches, they must be able to draw on the experience of others who have developed expertise with these new tools. This book presents a series of reflections and case-studies by such early adopters who have not just replaced older materials with new, but who have advanced the discipline's pedagogy in doing so. It illustrates how new technologies are changing the way art history is taught, summarizes lessons learned, and identifies challenges that remain. Given the transitional state of the field, with faculty ranging from the computer-phobic to the computer-savvy, these case studies represent a broad spectrum, from those that focus on the thoughtful integration of new technologies into traditional teaching

[1] Art History has always been taught with technology: see the essay by C. Witcombe, where he defines new technologies (p. 16) "as referring to any mechanical or electronic device that is made for and used as a means of reproducing and communicating images and information." Simply put, this means the use of computers and the internet. Although some of us prefer the term new media to new technologies to emphasize the vehicles we use for content and communication rather than the static physical infrastructure of the computer per se, the latter is more common and is used by the authors in this volume.

[2] See our survey of the scholarly literature in the section on Scholarship of Teaching, below.

to others that look beyond the familiar art history lecture or seminar format. They aim to provide both practical suggestions and theoretical models for historians of art and visual culture interested in what computer-mediated applications have been successful in art history teaching and where such new approaches may be leading us.

It is worth noting that most of these case studies are for introductory-level courses, where almost all of the conversation has occurred so far. This is due, in part, to the well-known problems associated with lower-level classes, which include large lectures covering too much material often attended by apathetic and passive learners, who frequently have no experience with art and yet are expected to be inspired and prepared for advanced study at the end of the term. Not only do these and other problems—challenges that are less acute in upper-division courses—lead us to look for new pedagogical methods, but they also represent common ground, because so many of us in the field have to teach them. We see several other reasons for this concentration of pedagogical research at the introductory level. First, they are taught nearly every term and hence provide frequent opportunities to experiment with, assess, and refine the use of technology in a given course. Second, these classes frequently function as general education courses, teaching basic skills and broad concepts to a large student population that typically has a low level of engagement compared to art history majors. Technological vehicles for course content and skill-acquisition tasks can provide opportunities to increase the engagement of these "gen-ed" students. Third, investments of time, infrastructure, and intellectual capital in an introductory course will affect a much larger population than will such investments at the upper division level. Colleges and universities are consequently more willing to provide funding for course development of freshman and sophomore courses. Fourth, in some ways, technology is already so well integrated into upper division instruction in the form of research tools that students use to teach themselves (e.g., ArtIndex), that it has disappeared into the background. At the same time, however, faculty are less willing to experiment with new technologies for the advanced courses, not trusting learning objects and other computer-mediated pedagogical tools for these courses in which the faculty members are more intellectually and professionally invested. Additionally, developing new tools and pedagogies takes time away from research and publication. In the current tenure climate in the United States, professors who devote substantial time to this endeavor may risk their own status at the university.

There are doubtless further developments to be made at the upper division level, perhaps most effectively if deployed in cross-disciplinary

contexts. But, the limited availability of institutional funding, small student populations, pre-existing high (or at least higher) level of student engagement, and relative infrequency with which these courses are taught constitute significant barriers to the investment of time, money, and expertise that such experimentation would require. Furthermore, faculty have developed a broad array of pedagogical approaches for advanced courses that have proven their effectiveness. Lacking a reliable corpus of scholarship demonstrating the value of computer-mediated pedagogy at the upper level, faculty are reticent to change tried and true methods in face-to-face undergraduate and graduate courses. As we reflect more regularly on program goals and learning outcomes, the benefits of interdisciplinarity and collaboration, and skill-building (rather than merely knowledge-giving), the integration of technological tools into our pedagogy holds great promise at every level.

Why Integrate New Technology Into Art History Teaching?

Art history involves more than looking. It asks students to think about what they observe. This is where technology-based activities become useful, especially those that go beyond the presentation of images to explore why images are structured the way they are, and what meaning that structure holds. Today, teaching in the history of art is being shaped by new technologies, technologies that—as has always been the case—were not developed for art historians, but which must be adapted for their needs.

The reasons for integrating new technologies are threefold. First and foremost, new technologies allow teachers and students to engage in new activities, and thus create new opportunities for teaching and learning. Second, research on cognition stresses the need for students to take control of their learning, something the interactive technologies can facilitate. Third, the integration of new technological tools and active learning techniques recognizes and responds to a cultural shift that has already occurred with our students and much of the society at large. As the shift from a print-based culture to an image-based one intensifies, the lessons art history teaches—that images are complex and one must learn how to read them—become increasingly important and necessary.

Essential Principles

New technologies for art historical instruction are here to stay. But many important corollaries to their use have yet to be discussed, such as understanding the social impact of the shift from analog to digital image,[3] parsing the level of investment required (financial and otherwise),[4] deciding who should control rights to computer-mediated teaching products (such as online courses and learning objects), recognizing the importance of scholarship of teaching, and enunciating guidelines for effective applications. The editors of this volume firmly believe these last should include the following.

- New technologies must be used intelligently and judiciously, not simply because they are available. Faculty should reflect critically on the pedagogical value of computer-mediated tools, embracing (and investing in) those that offer something that more traditional approaches do not. New technologies are extremely expensive and should only be deployed if they can accomplish something that paper and pen cannot. Resources are too scarce to jump at every new toy.

- Instructors should consider their pedagogical needs and goals before adopting a specific technology to their teaching. While the potential field of action presented by a technology can spark useful reflection, in the end, technology should serve the pedagogy, not the other way around.

- New technologies, either in support of face-to-face classes or used in online teaching, must be intrinsically and transparently linked to course and program learning outcomes, and their effectiveness should be rigorously assessed using empirical methods. Formative and summative assessments document the benefits of the learning technologies and their usefulness in art history instruction. Failure to integrate the new

[3] See the essay by Harris and Zucker in this volume on the culling of digital images as a solitary activity and the need to reclaim the social forum of the slide library.

[4] These vary widely as demonstrated in the essays here: from the largest public provider of online education in the U.S., the University of Maryland University College, which invests $25,000 on average in every online course (Allen p. 102) to the University of North Texas which offers grants of $10-20,000 for online course development (Donahue-Wallace p. 112). At the University of Massachusetts, La Follette and her colleagues developed eight learning objects with outside funding: these would cost between $12-15,000 apiece today. The latter could be disseminated nationally, while the online courses are proprietary to the institutions for which they were developed (though as Donahue-Wallace notes, UNT unusually allowed her to share the rights, p.112).

technologies with learning outcomes and assessment plans makes them little more than "add-ons" or "bells and whistles" rather than serious tools for learning.

• Instructors should not promote the technological system to the level of course content—if so, it becomes a distraction at best, another barrier to learning in art history at worst.

• Any experiments in pedagogy will yield some unexpected processes, side-effects, and results. Instructors (and those who evaluate them) should be open to these surprises, examining them for their usefulness instead of concluding prematurely that such unforeseen events represent failures.

• Instructors must establish a community of practice for sharing information about pedagogy and technology. Groups such as Art Historians Interested in Pedagogy and Technology in the United States and the Computers and the History of Art in the United Kingdom provide the opportunity to discuss innovations and their merits for art history teaching. Involvement in these or like groups helps faculty to avoid needless re-invention of technologies and methods. At the same time, larger organizations, such as the College Art Association and the Association of Art Historians, must embrace these and other societies as central to their missions to promote the study and teaching of art history.

By showcasing a variety of models, we hope this book will serve to advance discussion in these areas as well.

Computers in Art History Teaching

The use of computers in art historical instruction may be considered under three rubrics: first, the digitization of images; second, the development of computer-mediated interactive exercises using digital images; and third, the emergence of courses taught exclusively online.

The first, teaching with digital images instead of 35 mm slides is not a central focus of this volume, but it is nevertheless fundamental to the other two.[5] The teaching of art history has always relied on reproductions, and its nature has changed with each new method of reproduction. Replacing analog slides with digital images has several far-reaching repercussions, most notably increasing access to the reproduction outside of the

[5] Harris and Zucker consider the issue of slides versus digital images in their essay about the slide library, as does Witcombe, who traces the use of various technologies used in the teaching of art history over time.

classroom by students for review and study purposes. Professor Dana Leibsohn of Smith College (Read 2003) noted that her students became more adept at reading images closely and using visual evidence to support their arguments after they were given access to digital image banks. Before digital images, students typically saw the projected slide only in the lecture hall; to review images required going to their textbooks (where the reproduction was not always large or in color), or to a specific physical location on campus where hard copy reproductions were mounted temporarily for review. Digital images on a website now allow students to review images more easily, conveniently and often, thus encouraging greater familiarity with the works and more careful study.

In class, faculty employ PowerPoint or other presentation programs filled with digital images in the same manner as they did analog slides, projecting them singly or in static pairs. The ease with which textual information may be added alongside the projected image has offered instructors a slight advantage over the "write-on" slides of yesteryear.[6] The development of presentation software adds new functions including panning, zooming, selecting, and rotating. These tools surpass the static visual reproduction of the object to simulate in part the usual physical engagement the viewer has with a work of art: moving around it, approaching, and receding. With high quality images, some of the tools allow the viewer to see more than would be possible for the visitor standing in front of the object, as magnified images may reveal more than what is visible to the unassisted eye (Rhyne 1997).

Our second rubric, the development of interactive exercises known in computer-mediated instruction as learning objects has had as its goal the user's engagement with the object, concept, or question. The key repercussion here has been the adoption of active learning, a more student-centered and skills-based approach.[7] Art historical learning objects first

[6] Carlucci, Haubold and Stynes address the building of campus-wide digital image collections as successors to the departmentally-funded and based slide library.

[7] Two widely cited definitions of such active learning are John D. Bransford, Ann L. Brown and Rodney Cocking , eds. *How People Learn: Brain, Mind, Experience and School*, National Research Council. Washington, DC: National Academy Press, 1999: "New developments in the science of learning emphasize the importance of helping people take control of their own learning." and Chickering and Gamson, "Seven principles for good practice in undergraduate education", *AAHE Bulletin* (March 1987): "Learning is not a spectator sport. Students do not learn much just sitting in classes listening to teachers, memorizing pre-packaged assignments and spitting out answers…" For more on this concept, see the glossary on the American Historians' Visual Knowledge Project site (http://crossroads.georgetown.edu/vkp/resources/)

appeared in museum kiosks and websites, before spreading to schools. CD-Roms provided by textbook publishers and commercial vendors likewise promoted interaction. Using Macromedia's Flash or another interactive program, museum educators, publishers, and instructors have created animated activities, requiring users to drag and drop architectural elements, to click selected hotspots on a digital image for more information, or even to choose their own adventure in game-like situations. Used in art historical instruction, these tools have placed students in direct engagement with the reproduced work of art, allowing them to work more closely with images, empowering them as participants, and encouraging them to take an more active role in their learning in a way that is uncommon in the traditional lecture model.

The third rubric, the online course, is the most recent manifestation of computers in art history instruction. In the past five years, the number of colleges and universities offering online art history instruction has exploded, particularly at the first- or second-year level and most commonly at junior colleges and public, commuter universities. Many of these courses replace the face-to-face lecture with online materials. Some instructors rely on the textbook for course content, asking students to read the relevant chapter, and answer questions submitted electronically; many also require virtual visits to outside websites, including museum sites, to supplement the textbook. Other faculty substitute commercial videotapes for face-to-face lectures or move beyond the textbook content with additional instructor-authored html text. Many online courses use message boards, forums, chat rooms, and video conferencing for asynchronous and synchronous, seminar-style discussions. Blended or hybrid courses combine in-class experiences with small group, online, or other activities. Most instructors who author these courses do so based on their own intuition and experiences, or their colleagues', rather than on studied and proven methods from art history or other disciplines. In fact, the literature on online or hybrid art history courses and learning objects is woefully thin. The best practices emerging for online instruction differ from the traditional, lecture-driven instruction model, drawing upon the active learning and student-driven inquiry models described in our second rubric.

Looking Back: Strengths of the Traditional Slide Lecture

No statistics have been collected about the number of faculty who still use slides versus those who have gone digital, but clearly the traditional art history slide lecture is becoming less frequent across the country. It is important, however, to recognize its strengths, and to consider how to

maintain them as we move to technologically-driven ways of delivering curriculum. Generations of art historians have found their calling in darkened classrooms illuminated by the glow of projected slides. They have been enthralled by the professor at the lectern whose vast knowledge of the artists, objects, and monuments discussed in lecture seemed much more than could possibly be acquired in a single lifetime. Striding about the stage, the professor pointed to areas of the projected slide, revealing to the captivated audience hitherto unseen mysteries. Standing before pairs of projected images, the professor explained the visible differences or similarities, leading the students through a complex and edifying survey of artistic, historical, philosophical, religious, and social factors. These explanations frequently involved the professor's own research and personal tales of experiences in the archive, the museum, or the distant archeological site. Posing open-ended questions to the audience, the professor challenged the students to see the complexity inherent in studying works of art and architecture. Such performances inspired many undergraduates to pursue a career in art history, in part from a desire to emulate the professor and possess his/her knowledge, but also from the aspiration to add to collective art historical knowledge, and to make the discoveries that future art history students would learn about in their own darkened classrooms.

Looking Ahead: Problems and Challenges

This romantic tale of intellectual inspiration still plays out in some college classes, but the academic landscape is also changing for art historians. Although some faculty had begun experimenting with computer and digital technologies for teaching well before 2004, when Eastman Kodak decided to end production of slide projectors, that decision forced the majority of art historians into a largely unfamiliar digital realm. Those more comfortable with these new technologies see their potential to offer a more dynamic way of learning than static slide projection, but often lack the technical knowledge and financial resources to pursue such new approaches. At the same time, institutions seeking cost-effective and revenue-generating classes view online and blended or hybrid learning as the answer. They likewise strive to improve learning outcomes and turn to technology-mediated instruction as a promising solution. The instructors at these schools, however, have little experience with the technologies or the literatures that would help them to transform their teaching. Students, on the other hand, are increasingly technologically-savvy: they judge electronic tools used in class as they would commercially marketed

products and they expect courses to engage them in ways that art history's traditional "art in the dark" lecture format cannot. With their laptop computers open to take notes, many of these multi-tasking students now simultaneously use the university's wireless connection to surf the Internet, chat with their friends, and otherwise disengage from the learning environment, in traditional-style lecture classes.

So how can art history's slide-based courses and their emphasis on visual literacy, analysis, and research be translated into technology-mediated formats in a manner that preserves the discipline's best pedagogical practices while simultaneously adding fruitful new approaches to teaching? What should instructors adopt from other fields and what can they additionally develop for art history's specific needs? And finally, how can instructors today inspire the next generation to pursue the discipline as they had been led to do by their own teachers?

Scholarship of Teaching[8]

Part of the challenge for developing pedagogically sound and constructive learning objects and technology-mediated courses, and in publishing the practices and analyses of these tools, is the dearth of published information about pedagogy and assessment in the discipline of art history. Art history is an academic discipline largely lacking a body of pedagogical literature or a venue for publishing new scholarship in this area. The discipline's emphasis on object-oriented research and theoretical reflection has ignored pedagogy. Rich in historiographies of its research and writing practices and keenly aware of its modes of scholarly inquiry, art history has yet to examine its teaching seriously. The College Art Association's *CAANews* September 2005 issue admitted the lacuna in the article "Building the Literature of Art Pedagogy" in which author Robert Bersson lamented the lack of literature on teaching in our discipline.

With a handful of exceptions, such as Robert Nelson's (2000) thoughtful consideration of the slide lecture, the most developed area of art historical pedagogical literature addresses how art history has selected the works taught in its classes, particularly the large survey courses. Articles published in the College Art Association's *Art Journal* in 1995

[8] The editors of this book follow Lee S. Shulman's definition of this term: "A scholarship of teaching will entail a public account of some or all of the full act of teaching—vision, design, enactment, outcomes and analysis—in a manner susceptible to critical review by the teacher's professional peers and amenable to productive employment in future work by members of that same community" (Hutchings 1998, 6).

considered how the art historical canon presented in survey courses was developed and how a handful of higher education institutions were abandoning the notion of a single, Western canon dominated by dead, white, male artists.[9] Other articles addressed teaching and assessment strategies such as incorporating writing and abandoning the hallowed "darkness at noon" lecture format. In 2005, the *Art Journal* again looked at art history teaching, addressing how the art history survey is and might be taught. Non-traditional pedagogies, assessment issues, and learning styles also received some attention in this published roundtable discussion. The College Art Association's *CAANews* briefly considered the potential of problem-based learning in art history (Lindner 2005).

Scholarship on computers in art history instruction is similarly limited. While digitization and digital projects have received some attention, the scholarship on teaching with digital images is minuscule.[10] In 1997 the College Art Association's *Art Bulletin* dedicated part of one issue to digital images in art and art history; several of these short essays addressed teaching. Marilyn Aronberg Lavin offered the most radical reinvention of art history teaching, whereby the slide-based lecture is replaced by student-generated searches of digital images and texts. The abstracts and proceedings of the annual conference of the British society Computers and the History of Art (CHArt) do regularly consider teaching with digital images (Costache 1998, Bailey and Graham 1999, Greenhalgh 2001), but when compared to the scholarship on art historical research, these pedagogical publications are few and far between. The scholarship on learning objects in art history is equally small, with only a handful of articles (Cason 1998, Hamilton 1999, Donahue-Wallace and Chanda 2005) considering their role and effect in art historical instruction. The most sustained considerations of learning objects appear in the CHArt publications (Cock 1997, Levy 1997, Hamilton 1999, Clancy 2001, Gordenker 2002, Pollini 2005). Finally, of the three areas of computer-mediated art history we consider here, online pedagogy has received the least attention in scholarly publications (Briggs 1997, Maddox 1997, Schmidt et al.1999, Lahav 2001, Kwastek 2003). What is particularly lacking are qualitative or quantitative studies of the effect of the online

[9] See for example Bradford R. Collins, "Rethinking the introductory art history survey," *Art Journal* 54 (1995): 23-89.

[10] One might compare in the field of American studies, for example, the review by David Jaffee of electronic materials for the teaching of American history: "Scholars will soon be instructed through the eye: e-supplements and the teaching of U.S. history," *Journal of American History* (90.1) 2003, 1463-82, available online at http://www.indiana.edu/~jah/textbooks/2003/jaffee.shtml

environment on art history learning or pedagogical strategies for teaching in this new arena.

Art History cannot progress in developing a body of scholarship treating the pedagogical issues specific to the discipline until we also recognize that pedagogy is an academic field of its own, and that the scholarship of teaching in art history is just as interdisciplinary and rigorous as traditional intersections with other areas such as literature. This particularly impacts younger practitioners in art history who are finally beginning to receive some formal training in pedagogy in graduate school, and who will thus be well-equipped to advance the field in this way. As their senior colleagues, we should be prepared to consider valuing such publications towards tenure the same way we weigh traditional object-oriented or theoretical research.

Overview of the Contents

The essays in this volume amplify dramatically the available literature on computer-assisted art history teaching. The first section of the book examines broad questions on the state of technology-mediated instruction and assessment in art history. The first essay, written by Christopher L. C. E. Witcombe, a pioneer in digital resources for art historians, addresses technology-mediated instruction broadly. It combines practical issues, philosophical reflection, and guidance for those entering this arena. The second, by Stephen Carroll, sketches the dangers, for both teachers and students, of thoughtless and uncritical implementation of new technologies and recommends a careful application of computer technology where this supports teaching and learning. The third, by Beth Harris and Steve Zucker, reflects on the slide itself, and asks how the community of the old slide library can be extended into the digital realm.

The second section presents an array of computer-assisted learning objects and other activities that augment the face-to-face class. In order to help readers replicate the models presented, these essays and those in the following section, address the identification of a need, funding, design and development, pedagogy, assessment, implementation, and results. Laetitia La Follette looks at the benefits of adaptation rather than radical change and the impact of interactive learning objects developed as homework to help students acquire skills needed for the art history survey course. Robert Carlucci, Alexander Haubold, and Jeremy Stynes consider the creation of interactive learning objects in support of art history courses at Columbia University, tracking the changes in the use of technology over several years, and reflecting on the changing role of the visual resources

curator. Stephen Carroll, Dolores laGuardia, and Andrea Pappas examine a team-taught approach to teaching art history and composition with the assistance of a course-management system. Eva R. Hoffman and Christine Cavalier end this section with a close examination of computer-assisted concept maps that allow students to make cross-cultural connections in art history survey courses.

The final essays in the book address online courses. Eva J. Allen narrates the development and implementation of an online art history survey course, explaining how she reconciles art history's traditional pedagogy with the potential of the computer-based course management system. Kelly Donahue-Wallace compares two models of online courses, comparing the relative merits of redesigning the art history survey course using problem-based learning to the advantages of a more instructor-directed approach. Geoffrey Simmins examines strategies for engaging online students, offering instructive narratives from his own experiences encouraging distributed learning students to participate in course discussions. Allen and Donahue-Wallace bring this section to a close with a co-authored chapter reflecting upon the state and future of online courses.

Teaching Art History with New Technologies. Reflections and Case Studies holds up a mirror to the discipline's diverse applications of computer-mediated pedagogies and offers art historians and others the opportunity to learn from the successes and failures of early pioneers and to benefit from their experience. The authors' practices and specific technologies differ; their institutional support and individual paths into the technology arena vary as well. Uniting all of the essays, however, is a recognition that the discipline's use of computer applications, Internet resources, and other technological tools must be driven by thoughtful reflection on art history's needs and be implemented in concert with strong pedagogy.

PART I

REFLECTIONS

CHAPTER ONE

BYE BYE, SLIDES
BYE BYE, CAROUSELS
HELLO, INTERNET
I THINK I'M A GONNA CRY-Y

CHRISTOPHER L. C. E. WITCOMBE

There are a couple of interlocked issues that I think are useful to lay out on the table at the outset and to keep in mind when reading this essay and those following in this book. Perhaps we can use some familiar terminology to describe the situation. The first issue concerns form and content. On the one hand we presume the existence of a discipline of art history, which gives form and structure and defines our approaches to its content, which is the art. Or, to put it another way, the *history* part of art history encompasses our methodologies, while the *art* part of art history indicates that to which we apply those methodologies. Which one is or should be paramount – the art or the history – is debated every so often in association with the question of whether the discipline should be called art history or the history of art. Distinctions between the two are sometimes made around the question of whether we are constructing a history *of* art, with an emphasis on identifying and refining our understanding of matters of style and iconography which serve as the means for devising historical continuities among art objects, or whether we are examining art *in* history, with the emphasis placed on art and its role, place, function, meaning, and so forth, within the context of the historical moment in which it was made or later appears. Although these distinctions – form and content, art and history – quickly lead to the old chicken-or-egg problem, they are valuable in the way they force us to think about what we are doing as art historians.

With respect to the form and content of art history (or the history of art, if you prefer), it has generally been the case that what we teach mostly in the classroom is *content*. Matters of *form*, in which the aims, goals, and

purpose of art history and the methods, approaches, philosophies, and theories we utilize as art historians to reach those ends, are usually relegated to methodology courses, theory courses, and senior seminars. But of course when challenged on the matter of form (and the challenges brought to the discipline over the past 30 years have greatly contributed to our awareness of this issue), we readily acknowledge that form informs every aspect of how we treat content. Simultaneously, we would also acknowledge that content has in turn guided and shaped the selection and application of form in both general situations and specific instances. Today we recognize that the inclusion of new types of content, such as film, and challenges to the conventional canon of content, have given rise to new approaches and methods of analysis. With a certain arrogance that assumes our forebears (i.e. art historians working before 1970) were generally ignorant of such issues, today we pride ourselves on our special sensitivity to the interrelationship of form and content in art history and our clever and insightful understanding of how it shapes the discipline. Indeed, many instructors today, including some of those contributing to this volume, are seeking ways to incorporate a greater awareness of form into their courses.

Having placed these familiar issues on the table, I want to add another: technology. To the same extent that methodologies have determined how art historians deal with content, it is important to recognize the extent to which technologies have also shaped the discipline. This may sound like a rather tendentious claim, especially in a book like this one, but it is not difficult to show that the trajectory of the discipline of art history – both in its selection of content and the methodologies through which that content has been addressed – parallels innovations in communication technologies. It is important to recognize the impact of technology on the development of the discipline of art history because we are currently in the midst of a major technological revolution. Digital technology is transforming the world around us. In the same way that previous technological innovations shaped the form and content of the discipline, there is every reason to believe that art history will be transformed by digital technology. Indeed, this transformation is already underway. It is no mere coincidence that the new field of Visual Culture has emerged alongside the World Wide Web. The eleven essays contained in this anthology describe various exciting new ways in which computer-based technology can be used to teach art history. In addition, these essays also begin to articulate shifts in the discipline and I urge the reader to be alert to how the technology itself is beginning to alter how we think about the form of art history.

The following offers a brief review of the relationship between art history and technology drawn in large part from my online essay *Art History and Technology*.[1] I use the term technology in a broad contemporary sense as referring to any mechanical or electronic device that is made for and used as a means of artificially reproducing and disseminating (communicating) images and information. None of the technologies mentioned below was devised or invented specifically for the use of art historians, but in each instance they provided a means by which the discipline could pursue its special interests, even as those interests themselves were necessarily adjusted to suit the parameters or opportunities that the new technologies made available. The point I wish to stress is that in the process of adjustment and adaptation, the discipline itself underwent changes. Technology has not only shaped and guided the discipline in the past, it continues to do so. Much of what art historians do today in the study and teaching of art history is due to (and is done at the mercy of) technology.

The discipline we practice today emerged during the Renaissance hand-in-hand with the new technology of the printing press. The ability of the printing press to provide multiple copies of books and prints contributed significantly to art history's development. Giorgio Vasari in the sixteenth century was able to take advantage of the printing press to produce multiple copies of his book of artists' biographies, which immediately provided both a framework and a methodology for the study of art history.

At the same time, the presses were also churning out multiple copies of woodcuts and engravings. By the time the first edition of Vasari's *Lives* was published in 1550, Europe was awash in prints. A large number of the prints produced at this time were "reproductive" in that they reproduced other works of art, including paintings, sculptures, and architecture. For the first time, someone in Antwerp or Paris could see an image of an altarpiece or a fresco in Rome. Prints were actively collected and through them a person could supplement a study of art with reference to examples in distant places. Prints were portable and relatively inexpensive and were used also as illustrations in books.

During these same years (we are still in the sixteenth century), there also emerged the institution of the art academy, first in Florence then in Rome, where instruction included studying examples of ancient art, mostly statues and reliefs. When original examples of antique sculpture were not available firsthand, students could study prints, but a preferred solution

[1] This essay is available at http://witcombe.sbc.edu/arth-technology/.

was reproductions of ancient sculpture in the form of plaster casts. The making of casts of sculpture from plaster of Paris was not a new technology, but it was a technology nonetheless that was utilized by art academies who acquired casts in order to increase the range of examples available to those studying art. By the eighteenth century, practically every art academy in Europe was in possession of a collection of plaster casts of ancient sculptures. The availability of casts and prints greatly expanded the scope of the study of art history. It was now possible to compare and contrast a statue or a painting in Rome with a statue or a painting in Paris. This ability quickly came to define a central activity for the art historian. However, as the study of art history took shape around "study aids" – reproductive prints and plaster casts – the art history lecture simultaneously became more difficult.

The roots of art history teaching can be traced to lectures given at the new art academies. The first program of lectures was that organized in 1594 by Federico Zuccaro, the *Principe* of the Accademia di San Luca in Rome. At first lectures were given by artist-members of the academy, but beginning in the seventeenth century lectures by members who were not artists were also included. When Giovanni Pietro Bellori set forth his artistic theories in an essay read to the members of the Accademia di San Luca in Rome in 1664 (later published as the preface to his *Lives*), he included references to various paintings, such as Raphael's *Galatea* and Guido Reni's *St. Michael,* as well as to ancient sculptures which could not be seen by the audience there in the lecture room. As far as we know, Bellori did not use any "visual aids." In other words, his lecture was not illustrated and so he had to rely on the assumption that his audience would be familiar with the works he mentioned.

But because the discipline is fundamentally a visual one, there is a strong desire to show the audience what is being described. But, how was this to be accomplished in a lecture? The useful "study aids" (prints and plaster casts) are practically useless as "visual aids" in the lecture hall. It is difficult to move full-scale plaster casts into the lecture hall as needed, while copper-plate prints, which are generally rather small in size, would be difficult to see from the back. The desire to find some way to illustrate art history lectures resulted in some cases in the laborious production of enlarged drawings and diagrams. In the eighteenth-century, John Soane, who lectured at the Royal Academy in London for nearly thirty years, amassed some 2,000 display drawings of architecture, most of them measuring four feet by two feet and coloured for effect (the collection is still housed in Sir John Soane's Museum in London). Photographs, after they became available in the 1840s, alleviated the problem of reproduction

but were otherwise of little help in the lecture hall because, like reproductive prints, they were usually small in size. What was needed was some form of enlarged photograph. Technology came to the rescue in 1850 when two brothers in Philadelphia, William and Frederick Langenheim, invented a transparent positive image of a photograph in the form of a glass slide that could be projected onto a wall or screen using a Magic Lantern.

The practice of using a Magic Lantern to project images on glass plates was by no means new. An illustration in the 1671 edition of Athanasius Kircher's *Ars Magna Lucis et Umbrae* shows a type of Magic Lantern with images projected onto a wall. In an earlier edition of the same book published in 1646, Kircher had included a description of a way to project images using sunlight or candlelight and employing a convex lens as the means to focus the images. Kircher's images, though, were drawn directly onto the glass. The innovative feature of the Langenheim's invention was that the glass slides (called a "Hyalotypes" after the Greek term *hyalo* meaning glass) were made of actual photographs.

The technology developed quickly. By the 1870s, Magic Lantern projectors were using limelight as the source of illumination. (Limelight is a dazzling white light that was produced by directing a very hot flame onto the surface of a pellet of lime.) In 1873, Bruno Meyer, a German art historian at the Polytechnic Institute in Karlsruhe, was using projected lantern slides in his lectures. In 1892, electric Magic Lantern projectors were introduced. This new technology was enthusiastically adopted by Hermann Grimm, a professor of art history at the University of Berlin. In an article published in 1897, he reports how lantern slides permitted the projection of works full-size, or allowed small works or fragments to be enlarged to colossal scale. Grimm's successor at Berlin, Heinrich Wölfflin, also embraced the new technology. Wölfflin used slides extensively and was the first to utilize two slide projectors together so that he could show details alongside the principal image, or show different images side-by-side. Through his utilization of a new technology, Wölfflin introduced a new way of teaching art history. His method of compare-and-contrast was quickly recognized as an effective teaching strategy and continues to serve as a valuable pedagogical tool for art history instructors today.

At this time, lantern slides were black-and-white (although they were frequently hand-tinted with transparent colours). Prints and illustrations in books were also black-and-white (although they too might be hand-tinted). (The Alinari Brothers had established a photographic workshop in Florence in 1852 and, beginning in the 1860s, photographs of artworks could also be purchased from Adolphe Braun. By the 1890s photographs

were of sufficiently high quality to be employed by art connoisseurs, such as Bernard Berenson.) It could be argued that when using black-and-white printed images and black-and-white lantern slides, art historians tended to focus on those elements in an artwork that did not rely on colour. It may have been the absence of colour in the "visual aids" at hand that contributed to a growing emphasis in art historical discourse on matters of *style* and on those formal aspects of a work of art, such as line and shape, as well as matters of composition and proportion, which could be analyzed and discussed without having to pay too much attention to colour. The neglect of colour (with discussion of pigment, colour relations and composition, and tone) as the analytical focus of a painting perhaps stems from this black-and-white era in the history of the discipline.

The absence of colour in reproductions may have contributed also to a shift in interest among art historians such as Erwin Panofsky to the more visibly accessible questions of iconography.

In 1916 the German company Agfa invented a process for producing colour lantern slides, but because of the First World War the invention did not become available outside Germany until the 1920s. A major technological advance occurred in 1936 with the discovery of the Kodachrome three-colour process that allowed for the production of colour 35mm slides. Art historians, however, remained skeptical of the accuracy and authenticity of the colour reproduced in 35mm slides and persisted in an approach that embraced either stylistic and/or iconographical analysis to the general neglect of colour and related compositional features.

There are, of course, problems with all these forms of reproduction (prints, photographs, slides). Roger de Piles was perhaps the first to express misgivings about the uses of engraved reproductions. A little later, in the Preface of his *History of Ancient Art*, we find Johann Winckelmann (1880) railing against the inaccuracies and errors found in reproductive engravings. As Susan Lambert points out in *The Image Multiplied* (1987), it was sometimes the case that the reproductive engraver was not even working from the original, and thus the potential for error was increased. More recently, William Ivins, in *Prints and Visual Communication* (1953), has discussed how reproductive engravings have the effect of removing works from their original contexts. They also arbitrarily reduce or enlarge their scale.

Photographic reproductions are also flawed. The art critic John Ruskin was among the first to embrace the new Daguerreotype photograph (invented by Louis Daguerre in 1839). Writing to his father from Venice on 7 October 1845, he tells of buying "some most beautiful, though very

small, Daguerreotypes of the palaces I have been trying draw.... It is very
nearly the same thing as carrying off the palace itself; every chip of stone
and stain is there..." However, despite his enthusiasm for Daguerreotypes
of architecture, when it came to photographs of paintings, Ruskin
acknowledged their drawbacks. In Letter 59, dated November 1875, he
reminds his readers in reference to a photograph of Fra Filippo Lippi's
painting in the Uffizi of the *Virgin and Child and St. John*, "that a
photograph necessarily loses the most subtle beauty of all things, because
it cannot represent blue or grey colours, and darkens red ones; so that all
glowing and warm shadows become too dark."

Some art historians, such as Carl Justi (1832-1912), professor at the
University of Bonn and Berlin, rejected photographic reproductions of any
sort. He believed that machine-made images corrupted the eye and, despite
their apparent fidelity, distorted the original. Slides, too, provide drastic
paraphrases of the original and produce a false impact, both aesthetic and
psychological. We all know this to be true. At least the nature and form of
reproductive prints and photographs prevent us from confusing them with
the originals they reproduce. But, we tend to take the visual evidence of
projected images in the classroom pretty much at face value. You may
have noticed how slides have become more than a substitute for the
original artwork. In the classroom, when the next slide appears on the
screen, how many of us are guilty of saying "This is Botticelli's *Birth of
Venus* painted in...." when, in fact, the projected image shows not
Botticelli's painting but a slide or a digitized image derived from a
photographic reproduction.

To the extent that photographs and slides have influenced how art
history has been studied and taught over the past century or so, it can be
safely assumed that the new digital technology will have a similarly
profound impact. It is impossible at this point of development to see what
form and direction the discipline might take because, by all accounts, the
revolution in digital technology and communication has only just begun. A
glance back over only the last twenty years quickly reveals that new forms
of technology are constantly being developed; twenty years ago it would
have been impossible to imagine the types of software and hardware we
have now. There is no reason to assume that these developments have
reached a plateau; rather, there is every indication that the revolution in
technology is going to continue and produce software and hardware that it
is currently impossible for us to imagine.

The situation we are in today may be likened to that encountered in a
letter John Ruskin wrote to his father from Venice in 1846 in which he
marveled at the new Daguerreotype photographs calling them "the most

marvelous invention of the century." Ruskin was certainly right in recognizing the value of photography, but in 1846 he could not possibly have imagined what lay ahead. Four years later, in 1850, the Langenheim brothers invented the Hyalotype, as was noted above. In 1916 colour glass slides became available, followed in 1936 by colour 35mm slides. At the same time, the technology of photography also brought forth moving images, cinematic film, IMAX movies, and even 3-D IMAX movies. So, what can we look forward to?

The new digital technology has already provided us with a greatly enhanced ability to conduct research and to study artworks. We have ready access through the World Wide Web to library catalogues around the world, to databases filled with data, to huge image resources, to information of all kinds on many thousands of Web sites. Questions that emerge during research and writing can be quickly answered. Bibliography can be easily compiled; images easily tracked down and just as easily downloaded for use. And this is just the beginning. Computer capacities, processing and Internet speeds, data storage, and image quality continue to improve. Because digital photography can achieve a degree of exact mathematical specification impossible to duplicate through the analogue chemistry of photosensitive film emulsions, it promises to provide a much more precise and accurate record of visual images.

The new technology already permits us to do things in the classroom we could not do before with slides, such as zooming and allowing three-dimensional objects to be turned. Other changes are likely to occur, such as pixel configurations that will enable the creation of large digital surfaces, such as walls and ceilings. A "classroom" with "digital walls and ceiling" would not need a projector, the information and images would appear on the surrounding surfaces. It is a short step from that to the replication of complete spaces and environments, such as the interior of the Sistine Chapel, or Chartres Cathedral, or Lascaux, with the additional ability to "move" in any direction; to zoom to any part of that space to examine details close up. Other structures now in ruin can be reconstituted and viewed in a similar manner. Soon it may be possible to simulate three-dimensional objects, such as statues and buildings, in the classroom space. Scale could be manipulated and set to "actual size" if desired.

Not only what we do in the classroom, but the classroom itself may become transformed into a computer-based three-dimensional graphical environment, a virtual world of a type inspired by Neal Stephenson's 1992 cyberpunk novel *Snow Crash*, where instructors and students meet and interact in the guise of self-designed humanoid avatars. The virtual world *Second Life* currently hosts twenty or more colleges and universities in

England and the United States (though none of them offer as yet classes in art history). Such simulated environments could further alter how the discipline is conducted.

How computer-based teaching strategies such as those presented in this volume will transform the discipline of art history is difficult to say at this stage of the digital revolution. What I do see occurring is an increased inter-functional closeness in the relationship between computer-based technology and the teaching of art history to the extent that a new sort of symbiotic existence will emerge. Happily, as both a tool and a medium, digital technology is especially responsive to the changing needs of art historians today and this bodes well for the future of the discipline. Art history is currently in a transitional phase and will soon emerge, I believe, to play a greatly enhanced and newly vital role in the twenty-first century.

CHAPTER TWO

DANGEROUS ROMANCES:
THE RHETORIC OF TEACHING
(ART HISTORY) WITH TECHNOLOGY

STEPHEN CARROLL

How to use the latest technology to improve teaching has been a fraught question in the Western tradition essentially as long as that tradition has existed. In the *Phaedrus*, Plato warns teachers that a new technology—writing, will not have the beneficial effects its proponents claim. Toward the end of the dialogue, Socrates relates a story wherein the Egyptian god Theuth, inventor of writing, presents his innovation to the pharaoh. He claims that it "will make Egyptians wiser and will improve their memories" (274). The pharaoh, Thamus, rejects these arguments, saying:

> Theuth, my master of arts, to one man it is given to create the elements of an art, to another to judge the extent of harm and usefulness it will have for those who are going to employ it. And now, since you are father of written letters, your paternal good will has led you pronounce the very opposite of what is their real power. The fact is that this invention will produce forgetfulness in the souls of those who have learned it. They will not need to exercise their memories, being able to rely on what is written, calling things to mind no longer from within themselves by their unaided powers, but under the stimulus of external marks that are alien to themselves. So it's not a recipe for memory, but for reminding, that you have discovered. And as for wisdom, you're equipping your pupils with only a semblance of it, not with truth. Thanks to you and your invention, your pupils will be widely read without benefit of a teacher's instruction; in consequence, they'll entertain the delusion that they have wide knowledge, while they are in fact, for the most part incapable of real judgment. They will also be difficult to get on with since they will have become wise merely in their own conceit, not genuinely so (274-5).

The striking way that Thamus not only denies Theuth's claims, but shows how the technology he advocates will create a result exactly the opposite of what Theuth claims, warns us to beware of the purveyors of new technologies. Blinded by their passion for their own inventions, Thamus argues, they cannot accurately judge the likely outcomes of their use. The fact that a god was so completely and thoroughly wrong emphasizes the seductive power and the danger of this new technology. As a god, Theuth is Thamus' superior, so we can also interpret this passage as a warning against allowing supervisors to make decisions about the use of new technologies. From this perspective, we see Theuth as the originator of the idea that we should use the technology a certain way. The argument about the bias of sponsors applies again here, but the psychological detail of Thamus' response suggests another argument as well: supervisors are unable to accurately judge technology's effects because they lack the connection to the audience who will be affected.

The substance of Thamus' arguments is also relevant: Thamus—and Socrates—reject this new technology because it inhibits learning. Writing, they suggest, reduces students' ability to own their own knowledge: if they don't have to "exercise their memories," students' memories will lose capacity and flexibility; the same lack of exercise will make students mentally lax and lazy; eventually, they will cease even to expect themselves to remember what they learn. As students come to "rely on what is written," rather than on what they know, they become less self-sufficient and independent in their thinking. Thamus' description of writing as "external marks that are alien to themselves" draws attention to the way this technology makes students and their learning depend on itself—something beyond students' control. The lesson here is that a new technology causes students to pay attention to the technology itself instead of the purpose it serves; it thereby alienates students from their own knowledge and capacities, reducing their ability to learn.

Perhaps even more important, writing appears to obviate the need for teachers, so that even as it reduces students' capacities, it fosters a dangerous false confidence and makes them more difficult to teach. As the dialogue progresses, Socrates expands upon the issue:

> Writing...has this strange quality about it, which makes it really like painting: the painter's products stand before us quite as though they were alive, but if you question them, they maintain a solemn silence. So, too, with written words: you might think they spoke as though they made sense, but if you ask them anything about what they are saying, if you wish an explanation, they go on telling you the same thing, over and over forever. Once a thing is put in writing, it rolls about all over the place, falling into

the hands of those who have no concern with it just as easily as under the notice of those who comprehend; it has no notion of whom to address or whom to avoid. And when it is ill-treated or abused as illegitimate, it always needs its father to help it, being quite unable to protect or help itself (275).

Here, Socrates focuses our attention on the fact that words must always be interpreted—we must decide what they mean. But it is possible for a student's interpretation to be mistaken, in which case the wrong learning takes place. Thus, while writing appears to allow students to learn without teachers, in fact it increases the need for them. In spoken discourse, teachers guide students' interpretations by asking and answering questions to verify that the students understand and learn. They constantly and seamlessly adapt their words to the particular needs of the audience so that the focus remains on the ideas being discussed. Writing distorts the process of interpretation because it makes the words themselves—as opposed to the ideas—the object of interpretation. The technology thus distances the teacher from the learner and creates a barrier between them. The technology also reshapes the teacher's role: teaching is mediated rather than direct, so the teacher becomes an interpreter rather than a primary source of knowledge. Moreover, because the technology increases students' confidence in their own knowledge and reduces their capacity for "real judgment," it emboldens students to assert their misapprehensions as real knowledge and to resist correction. In this way also, the technology creates a more urgent need for teachers, yet erects new barriers that make teaching and learning more difficult.

To sum up, Socrates brings three indictments against incorporating new technologies into teaching: 1) new technologies have a seductive power that blinds those who invent them and those who sponsor their use, such that they are unable to predict the actual consequences of teaching with the technology; 2) new technologies blind students as well, causing them to focus on the technologies (rather than the purposes they serve) and to become dependent on them, distracting students from the task of learning and reducing their thinking skills; and 3) new technologies create false beliefs about teaching and learning that appear to reduce the importance of the teacher and create barriers that hinder teaching and learning. Recalling that *Phaedrus* takes rhetoric as its subject matter, we can see that all three points concern ways technology distorts the relationships between teachers and their audiences. We might observe as well that in all cases, Socrates puts learning—which is to say, the needs of the students—first.

We would be wise to heed Plato's warnings, because the points that he makes about writing apply equally well to present efforts to integrate personal computer-based technologies into humanities classrooms. His warnings are especially relevant to art history, since it is has historically been more closely wedded to current technologies than most other humanistic disciplines. Since its inception, art history has depended on two technologies, one that allowed accurate and relatively inexpensive reproduction of images, and another that manipulates light so as to illuminate those images (pun intended) in ways that make them accessible for teaching and research. Because art historians were among the first academics to build pedagogies around these new technologies, and because they have taken rapid advantage of advances in these tools as they have emerged, art historians became accustomed to thinking of themselves as leaders in technological applications in the humanities.

Over the past twenty years or so, however, art history's technical leadership has slipped. Now art historians often look enviously at fields like English and history, where instructors incorporate blogs, podcasts, wikis and other forms of computer-mediated instruction into their pedagogies. Although individual instructors and institutions have developed pedagogical projects using digital technologies, art history as a discipline has suffered from fitful starts, expensive mistakes, and a general lack of direction. Many art historians long to return the field to the technical leadership position it formerly enjoyed.

External factors also contribute to an increasingly urgent need for a techno-pedagogical makeover. Eastman Kodak has stopped making slide projectors, film-based cameras and popular lines of slide film. The company is explicit about its desire to migrate users to digital formats. Other manufacturers are following the leader. These changes make it clear that maintaining the infrastructure required to support slide-based pedagogy will soon become prohibitively expensive, and then altogether impossible. As Maureen Taylor (2006) observes, "As digital imaging continues to evolve, it's likely that slides will become something to reminisce about much like other outdated processes like the daguerreotype." Recent transformations in the business world wrought by new digital technologies—changes in operations, in business models, in business culture—have led many school administrators to believe that they too must adopt these new technologies wherever possible or risk being left behind by their more technologically savvy competitors. Consequently, initiatives to integrate computers and associated technologies have proliferated rapidly at all levels, from local to state and from elementary schools to universities. As "consumers" of higher education, both students

and their parents place great emphasis on the extent to which digital technology is integrated into the classroom. More is always better. College Prowler's college rankings (2007), for example, includes Computers as an evaluative category and notes, "A high grade in Computers designates that computer labs are available, the computer network is easily accessible, and the campus's computing technology is up-to-date."

This urgent need to integrate computer technology into the art history classroom intersects with structural and institutional features of the humanities in dangerous ways. It is harder to integrate computers and other high-tech equipment into the humanities classroom than it is into physical and social sciences classrooms, where the use of computers is more established and more clearly applicable to the subject matter. This means that solutions that have worked well in other disciplines often don't work at all in humanities classrooms. It also means that what appear to be obvious solutions often have unexpected and undesirable consequences. Replacing the slide projector with an LCD projector and a computer running PowerPoint doesn't significantly alter the pedagogy, but it does create a host of new technological problems (e.g., creating and managing a digital archive, coping with the technical limitations of PowerPoint, interface problems, etc.).

More importantly, this push to incorporate digital technologies creates exactly the kind of distorted rhetorical relationships that Socrates warns about in *Phaedrus*. Much of this push comes from deans, provosts, and other administrators: people who are strongly motivated to approve digital techno-pedagogy projects, (not because they invented the technology, but) because they wrote the initiatives, are responding to pressure from their own superiors, or seek to improve the competitive position of their unit. According to Socrates, we must not trust their judgment because their investment in their projects warps their perspective. Socrates would also point out that in most cases, they lack the *technē*, or technical expertise, needed to evaluate the probable success of such projects. Because our culture (and hence these administrators' audiences) value digital technology so highly and so uncritically, if they lack this skill, it is all too easy to "blind them with science." Moreover, these people teach rarely, if at all, and therefore lack the connection to students that would enable them to discern whether a given techno-pedagogy will be effective or not.

This unusual rhetorical circumstance—having an audience that is strongly motivated to approve projects that incorporate digital technology into the art history classroom, yet which also lacks the perspective and expertise needed to evaluate the likely success of those projects—has led to a goodly number of failed experiments. In some ways, this is normal:

the bleeding edge always has a high casualty rate. So despite the poor taste that these failures have left in many people's mouths, they have not yet changed the fundamental dynamics of the rhetorical situation—the audience is still strongly motivated to approve high-tech projects and though they may be somewhat more skeptical about inflated claims than they were before, they are no more able to evaluate those claims than previously. Indeed, the excessively high value that our culture places on digital technology often means that despite repeated failures of techno-pedagogical projects, administrators continue to form expectations of success that far exceed even the stated goals of the project. At a recent conference, I overheard a conversation between two writing teachers. One said that her administrator had gotten 25 new computers for her classroom. As he delivered the news, he announced that since they came with Microsoft's new Vista operating system, she would now be "able to teach them anything." If they were connected to the network, "we wouldn't even need a teacher anymore."[1]

This fraught rhetorical situation places those who would increase the integration of digital technology into humanities pedagogy in a singularly responsible position. Because our audience is still unlikely to be able to evaluate wisely our proposals and experiments, and because they are often unable to control their expectations of our projects, we teachers must find ways to effectively communicate the real costs of our projects and their possibilities for success. We also bear the burden of proof for showing that we have been able to meet the goals that we set for ourselves.

But even then, we are only half-way home, because computer technology distorts our rhetorical relationships with our students in the same way that writing did for Socrates. It literally comes between us and them—especially in the case of distance learning. Our students, like Socrates', get caught up in the hype about the new technology and are distracted from the real purpose of its use. They pay attention to the technology, not to what they are supposed to be learning. They are also prone to confuse knowledge (or worse, the ability to find knowledge) with understanding and mastery. And because many (most?) of our students are digital natives, having grown up enmeshed in an environment rich with computer technology, they systematically overestimate their competence in using it, their understanding of it, and what they have learned by using

[1] Overheard at the International Writing Center Association Summer Institute in Corvallis, OR, August 6, 2007.

it.[2] This overestimation of their abilities produces exactly the same combination of ignorance, arrogance and intransigence that Socrates predicted.

But teaching with computer technology changes our rhetorical relationships with our students in even more pernicious ways than this. Most professors assume that their students are computer literate (Jenson 2004). Thus, when we roll out techno-pedagogical projects, we take for granted that students will have no trouble mastering the computer skills necessary to the task. Consequently, we don't teach them the specific technical skills they will need to reach the desired learning outcomes. We tend to assume that due to their technical skills, they will with minimal instruction figure out what they are supposed to do and to learn. But of course it doesn't work this way: just because a student can create a spreadsheet in Excel doesn't mean that they can create a pivot table, nor that they understand when and why they should use a pivot table. Moreover, our assumptions about their technical skills create an additional psychological barrier that makes it harder for them to learn. When we communicate our expectations of their expertise to them, we put them in a position where they can't ask questions without admitting that they don't know as much as we thought they did. Socrates had no problem admitting his own ignorance, but most adolescents are loath to give up claims to expertise. Once again, we have made it harder for them to learn.

To solve these problems, we can once again look to *Phaedrus*. To our knowledge, Socrates never wrote anything important—presumably for the reasons he outlined in this dialogue. But Plato did. The fact that he *wrote down* Socrates' teachings—including his criticism of writing—suggests that Plato thought that he had found a solution to the problem of how to use that technology without hindering effective teaching. He hints at his answer at the very end of the dialogue, where he writes,

> complete lucidity and serious importance... belong only to those lessons in justice and beauty and goodness which are delivered for the sake of true instruction and are, in fact, inscribed in the soul; such discourses as these should be counted as his legitimate children. (278)

"For the sake of true instruction" appears to be the key. Here Plato suggests that the purpose for using the technology counts: it can be used to teach, so long as the focus remains fully and truly on that goal. His statement that "true instruction" is inscribed in the soul" also alerts us to

[2] See, for example, Jenson 2004, especially pages 108-9. David Armstrong's soon-to-be-published data presents similar conclusions.

the fact that pedagogy is always personal, always depends on the audience and must be adapted to their needs. So when we use technology, we must take care that our use of it is also adapted to their needs in a way that it results in real learning. The dialogue itself models this process: by refusing to present a single, authoritative viewpoint, it requires the reader to ask questions, to think about the issues for themselves, to develop their own understanding of the ideas discussed. This keeps the focus off of the technology, allows the technology and message to adapt to the needs of the individual student, and promotes real learning. Because this way of using technology facilitates accomplishing the real goals of our projects, ironically, it is by de-emphasizing technology that we assume real techno-pedagogical leadership.

Plato's suggestions help us meet our enhanced responsibilities vis-à-vis our administrative audiences. Since we are unlikely to be able to significantly reshape this audience's understanding of digital technology, any focus on technology will distort the rhetorical relationship in ways inimical to success. By eliminating technology from the discussion, we remove most of the factors which deform our audience's judgment and over-amplify their expectations. Framing our projects in terms of pedagogy rather than technology also brings the conversation into a realm in which administrators do have technical expertise, and so enables them to judge our projects more accurately. This increases the honesty of our relationships and increases the likelihood of positive outcomes.

A relentless focus on pedagogy will benefit our students as well. If we emphasize the pedagogical purposes of our projects and downplay the use of technology, we model proper perspective and judgment: we demonstrate how to avoid being distracted by the means and to pay attention instead to the goals. We also short-circuit the connection which allows students to assume that because they can use the technology, they have understood the ideas. When the focus stays on what students need to learn, it is much harder for them to adopt that hubristic combination of ignorance, arrogance and truculence which closes their minds. Most importantly, if we stay focused on pedagogy, we will not forget that we need to teach our students what we want them to learn. We will remember that we need to provide them with explicit instructions about what we want them to do, how they are supposed to do it, what the outcomes are supposed to be, and what they are supposed to learn from it. Nor will we forget who our students are: a diverse group with widely differing experiences, abilities and levels of skill; people who don't yet know what they know and what they don't know (and who may be insecure about

some of that); and most importantly, people who look to us to help them learn.

Epilogue: Principles of Application

Examining the origins of a project often provides the clearest view of its focus. Did it begin with a clear pedagogical problem and then evaluate various technologies according to their potentials to solve that problem? Or did it begin when someone was exposed to a new technology and thought about how they could use it in their class (or department, school or college)? If the latter, the shoe is already on the wrong foot because the technology determines the pedagogy instead of the other way around. Even in the marginal case, where one finds a technology that will allow them to solve a pre-existing and recognized pedagogical problem, the power and allure of technology are so strong in our culture, that the technology—not the pedagogy—almost always ends up defining and driving the solution.

Our discussion provides a few principles to guide applications of computer-based technology to art history pedagogy:

- Begin with the pedagogical goals, never the technology.

- Think carefully about the kinds of changes you want to produce in your students: are your primary goals changes in understanding, skills, attitudes or habits? Different kinds of outcomes require different pedagogical approaches (and different uses of technology).

- Force yourself to articulate not only your larger objectives, but also concrete, measurable outcomes. Keep your focus on what students will gain, not how they will gain it.

- Align technology with the outcomes rather than the other way around.

- Educate your audiences about your project by stressing learning outcomes and pedagogical processes. Include any technological components only as means to those ends. (Avoiding jargon and using plain English to describe the technology will help keep the focus in the right place.)

- Never let the technology rise to the level of course content. (Note that this severely restricts the complexity of the technology you can use.)

- Always provide instruction to students about how to use the technology and what the goals of its use are.

- Assess regularly and frequently.

- Assess for learning, not teaching (or technology).

CHAPTER THREE

THE SLIDE LIBRARY: A POSTHUMOUS ASSESSMENT FOR OUR DIGITAL FUTURE

BETH HARRIS AND STEVEN ZUCKER

History credits the ancient Greek mathematician, Archimedes of Syracuse (c. 287 BCE–212 BCE), with the claim that he could move the earth if only it was possible to stand at some distance from it, such was the power of the lever. Over the millennia, the Archimedean point has come to refer to a position outside a given context, which provides a global, rather than local, view. Digital technology offers the ability to leverage the collective knowledge of larger communities than has ever been possible. Wikipedia is only the most evident example of the collaborative power of this new lever. Web-based tools that employ video, voice, image, annotation, tagging and remixing have expanded and transformed opportunities for creativity, and formed communities of interest that challenge the ivory tower of the academy. The external vantage point, that place of powerful singular objectivity, has been supplanted. The text is hyperlinked and annotated, and the image is increasingly so. Art historians must continue to examine these enhanced opportunities for collaboration and learning for our discipline. Clearly, the very notion of the image library as a single resource and as the exclusive preserve of faculty is one that has already been superseded. Similarly, the bibles of the art history survey—Gardner and Janson—have begun to give way to the extraordinary richness of multimedia content available on the web. What are the ramifications of these radical changes for our teaching and research? As we step away from the slide library, we are at a critical juncture that seems ripe for a bit of nostalgia but also for reflecting on the changes wrought by digital media and its apparatus on the teaching of art history and on the future of higher education generally. More specifically, we consider here the slide library along with the slide and the analog projector in their relationship to the history and teaching of art history. We also examine the current structures of digital media libraries and imagine what we may want in the future.

Our Attachment to the Slide Library

For decades, the slide library has surrounded us with a comforting visual representation of our discipline. Its broad categorical structures (based on geography, period, style, and artist), its hierarchies (the traditional fine arts before the ephemera favored in visual culture), and its emphases (nineteenth-century France occupies far more drawer space than nineteenth-century England or for that matter Mexico) were evident from the labels on drawers and cabinets. Yet each slide library was also organized somewhat idiosyncratically; predetermined categorical structures were only a starting point, and allowances were made based on the curator's intimate knowledge of the faculty and their usage.

The slide library also offered familiarity of another sort—it was a place to speak with colleagues in an informal context very different from the bimonthly agenda-driven department meeting. Conversations that took place there naturally turned to general teaching strategies and specifics such as image comparisons, visual learning activities, or museum assignments. The slide library was a place for mentoring new colleagues and, of course, for gossip. The slide drawer itself was a common space where slides were exchanged for markers, the traces of our choices, for others to see if they cared to. Like a public square, the slide library was also a place of surveillance, where which images a faculty member pulled or did not pull, or what they failed to return or share, could become fodder at the next department meeting. Both the content and organization of a slide library provided an intricate portrait of the ideologies, pedagogy, and personalities of a faculty rendered over decades. Although we built the analog image library and shaped its collection, the conversations that happened there shaped our teaching and research in turn. The slide library was thus certainly not a neutral repository but rather a normative force that nonetheless gradually responded to larger shifts in the discipline.

The transition away from the slide library has not been an easy or painless one. In the classroom, particular slides were intimately connected to concepts we wanted to convey to our students. Some faculty members were understandably reluctant to give up the favored images that were a critical part of their finely honed pedagogical narratives and that often acted as cues during their lectures. Despite the attachment faculty felt for specific views of cultural monuments (particularly sculpture and architecture, and painting in situ), the relative efficiency of digital images quickly converted the vast majority on our campus in a matter of just two or three years.

At our college, in midtown Manhattan, where space is at a premium,

we wonder what will become of our slide library in the next few years. The collection, constituted as it is of Ektachrome and Kodachrome, will surely deteriorate if new slides are not continually made and old ones discarded. Sadly, it is likely that most slide libraries will eventually be discarded wholesale. Space-hungry teaching institutions will not continue to allocate the resources needed to store and maintain their analog collections. Perhaps research institutions may have the insight to preserve their valuable and often unique collections. For example, the Institute of Fine Arts at New York University recently evaluated their lantern slide collection for its historical value (Rodda 2005). However, this assessment may prove overly pessimistic; several years ago there was concern that the position of the highly skilled slide librarian would become obsolete. The very idea now seems preposterous; image curators have become ever more essential as the volume of available material increases daily.

The Slide, Handmaiden of Modernism

The mounted slide, the laden oak cabinet drawers, and the glowing light table can now all be seen as occupying a specific historical moment in our discipline, one whose origins are situated firmly within the technological developments that accompanied modernism and whose demise—which we are witnessing—is an expression of what is sometimes referred to as high Postmodernism. Paradoxically, even in the age of mechanical reproduction, the slide maintained a degree of residual authenticity. After all, despite its *raison d'etre* as a reproduction, each slide is, in some important ways, unique. The mounts might be plastic, wood or glass, the labels printed on a laser printer, or typed on an IBM Selectric. The age of the slide was apparent from these mounts and the color degradation of the image itself (unless it was black and white). In the form of the slide, the reproduced image meets the beholder only "halfway," to use Walter Benjamin's term (1968). In other words, it is a subsidiary yet unique object that itself exists in one place at one time. In contrast, the digital image can be made to minimize quality loss and is potentially both ubiquitous and simultaneous.

In an academic setting, the value of the quasi-unique slide was pronounced. Slides that showed a particular view or detail, or that were especially high in quality, were rare and sought after. Students often needed to visit the office of the professor or the reserve area of the slide library to have access to the images shown in class. Now, although the instructor still selects the images for a given lecture, many images are far more readily available (of course reproductions of less canonical monuments can still be fairly rare). It is astonishing to recall that The

Frick Art Reference Library and the Courtauld's Witt and Conway Libraries amassed vast collections of reproductions of artwork and in certain cases even sought to record every instance of the publication of a reproduction of a given monument. In the pre-digital age, reproductions could accrue a certain value relative to the quality and rareness. In the context of the academic image library, the slide was neither a pure likeness nor, obviously, an authentic original, rather it was something in between.[1]

The word, "slide," refers to the way in which the image/object slid past the lamp of the projector, but it also suggests its movement across the light table as we ordered and re-ordered the sequencing of images for our lectures. In the art history classroom, there was always an awareness of the physicality of the slide, whether by the constant whirring of the projector's fan, the mechanical clicking of the mount sliding in and out of view, or by our request for "the next slide on the right." In a very material way, the framework of the magic lantern was apparent. In contrast, the digital classroom can be a quiet space, entirely removed from the objecthood of the slide or the mechanical apparatus that supported it. Enhancing a kind of modernist purity, the digital image appears to take on a magical quality, divorced from the very idea of the projected image as an indexical reproduction. There is no prompt for the audience to consider the distance of the reproduction from the original. As Benjamin noted about the reproduced image, but which is even more true of the digital image, "the equipment-free aspect of reality here has become the height of artifice; the sight of immediate reality has become an orchid in the land of technology" (1968, 233). Indeed, instructors most often insist on the elimination of the controls of the web-browser as a frame that might remind our students of the digital armature employed. Perhaps because of the modernist roots of our discipline, art historians have always preferred clean images that present an ideal view, often from the hovering position of a disembodied eye that centers the image free from car traffic, viewers, or the distortions of an oblique view. From such images, students gain no sense of physical context. Digital technology transforms the image from a still-somewhat-unique thing in the world, to a fully exchangeable currency, but one that

[1] Robert L. Nelson (2000, 415) makes a related point noting the impact of the lecturer, "In the slide lecture, the image, that shadow or representation on the wall, never remains mere projection, mere being, because it is part of a performative triangle consisting of speaker, audience, and image. If slides are tangible enough objects, and speakers and audiences readily recognizable subjects, their mutual interaction yields what Bruno Latour calls 'quasi-objects' and 'quasi-subjects." Together they create narratives and social bonds and transform shadows into art, monument, symbolic capital, or disciplinary data."

also presents us with an enhanced opportunity to re-contextualize the image, to surround it with the sounds of worshippers and tourists echoing against a vaulted ceiling.

Slide Library as Social Space

The heart of the traditional art history department, the slide library, its "town square" so to speak, has been unbundled and dispersed amongst Google, Flickr, ARTstor, YouTube, museum websites, faculty web pages, image galleries, and so many other sites and tools that exist outside of the preserve of the academy. We cobble together our lectures from these multiple sources, often encountering a myriad of frustrating hurdles. Impediments can include, for example, the inability to download high-quality images into a presentation tool of choice, a proxy-server, or even inadequate technology in our classrooms. Nevertheless, after years of marginalization in academia, the image is finally earning its place thanks in large part to social software. Sites like Flickr and Voicethread put the image front and center, finally allowing us to annotate an image by drawing on it or embedding text in it. However, such tools are not optimized for academic use and are not integrated into academic digital media libraries.

As we move from analog to digital, we wonder if these new tools adequately replace or compensate for the loss of the valuable social interaction of the slide library. Do the new communities of interest we now form beyond the walls of our institution and discipline compensate for that loss? Have we lost the serendipitous meetings that so often took place inside the slide library—conversations that were embedded in the fabric of the institution, the department and its students?

Many tools currently exist that could enhance and transform the image library into a personalized social learning environment unto itself. Unfortunately, digital media libraries have, for the most part, merely replicated the elements of the slide library—the individual images themselves, often in the forms we have grown so comfortable with, the mounted slide, and the light table. However, we are not close to having what we really need for our teaching: the ability to share high-quality images and multimedia easily and freely, to remix them, annotate them, ~~~m in class sites, add associative meta-data, understand how a 's used in other disciplines, and search across collections.

and Facebook have grown into vast communities by enabling orks. Websites like Amazon increase sales by actively titles based on a comparison of one user's data with that of

others, allowing for targeted suggestions. The irony of the digital image library is that, while we might be sharing a single image, we are alone in front of a screen. ARTstor and other digital image libraries were meant to allow for academic access to a shared set of images across disciplines and institutional boundaries, yet the experience of the digital media library currently inhibits the intersections of our work. So, in addition to replicating the opportunities for finding and sorting images in the new digital image library, we need to re-conceive opportunities for relationships between people and information. In other words, instead of an image library functioning as a passive repository from which images are retrieved, it can become an active arena for collaboration and thus an active learning environment. So the problem that we pose is this; how can we reclaim and extend the community of the slide library in the digital realm? How can we take fuller advantage of our Archimedean point?

Why Did We Bother? Or A Short Rant On The Current State of Digital Access

Like the virtual light tables digitally rendered within current repository and presentation software (Almagest, ARTstor, Luna, or MDID), instructors themselves often simply replicate the traditional slide show by seeking discrete images that are sequenced and compared as in a slide lecture. Art is divorced from its context, even when the opportunity for context is amply afforded by YouTube, Flickr, *Second Life* and the like. Architecture, sculpture, and painting in situ are all experienced spatially. What has kept us from showing video or three-dimensional recreations like the Sistine Chapel built by Vassar College in *Second Life*?[2] Any art history instructor who seeks to incorporate the rich resources of the web will encounter a number of significant problems. Images have to be acquired from disparate sources, some by googling, some by going directly to websites that have proved useful (such as the Web Gallery of Art), and some from ARTstor and institutional libraries. Learning management systems (LMS, also known as course management systems) like Blackboard are hardly conducive to the mashup.[3] Our lectures no longer need to be just a series of image comparisons (a form of teaching and learning encouraged by the one- or two-at-a-time nature of the slide), they might incorporate a photo-set taken by a tourist in the Pantheon and

[2] The Vassar College Sistine Chapel recreation can be visited at http://slurl.com/secondlife/vassar/165/91/24.
[3] Mashup refers to the merging of multiple tools into one application.

uploaded to Flickr, an online game about Renaissance patronage, a Quicktime video depicting the interior of the Arena Chapel, and increasingly, accurate recreations within *Second Life*. Wikis like Wetpaint allow faculty and students to collaborate on text and combine slide shows, videos, RSS feeds,[4] links, and still images to create a public learning space that has been completely personalized. For how long can we ask our students to move from public sites that enable networking and personalization into the closed space of the learning management system? As of this writing, we believe that part of the difficulty instructors face is trying to integrate software that exists beyond the LMS into the classroom. How many usernames can we ask a student to have? How many passwords? Finally and significantly, none of this extra-academic software offers compatibility with tools that facilitate assessment, like those found in any standard LMS. It may be simply too cumbersome to assess student work when it is dispersed among many different platforms, domains, and tools.

Social Research, Social Learning

Clearly, we do not currently have the right means to connect scholars and teachers of visual culture to each other and to related content. Social software enables communities of interest, and Web 2.0 puts the ability to create and remix nearly anything in the hands of every student and every professor.[5] We need to be able to engage in conversations (via blogs, wikis, bookmarking, chat, video and annotation), and to remix, distribute or publish content—and all this needs to be optimized for teaching and learning with images. We want to know who is looking at the same or related images whether in the classroom, in blogs, eportfolios, or student assignments.

How might this work? A search for an image of Van Eyck's *Arnolfini Wedding* might call up links to image comparisons used by other faculty, student projects, assessment tools, discussions, learning objects, or even perhaps to fifteenth-century Flemish textiles in the collection the university's museum, all created and updated collaboratively. Utilizing associative meta-data can make the material we teach more relevant to our students and aid us in breaking disciplinary boundaries. Imagine the

[4] Rss is a feed of regularly updated content. Users subscribe to a site's content and a news reader or aggregator program loaded onto their personal computers queries all subscribed sites for new content. This content is then automatically downloaded onto the user's computer.

[5] See Eva J. Allen's reflections on Web 2.0 in Chapter 11.

collaborative potential of an RSS feed created for a particular image; every time that image was reused or tagged we could be notified via our personal portal. Just this year, Open Library, a similarly comprehensive, networked, and community-constructed library was created for text (http://demo.openlibrary.org/about). There is clearly a need for an equivalent library for images though the term *image library* may no longer be appropriate. The singular form is less and less relevant as we engage in federated searching for images, slideshows, video and other content. Perhaps it is now more appropriate for the media library to be conceived of as both a point of entry and a collection of guides and tools that assist in navigating the vast resources that are quickly coming online. Although limited, ARTstor is a brilliant effort to produce a single sharable image library that makes it unnecessary for every art and art history department across the country to scan its very own copy of, for instance, the *Mona Lisa*. Our isolated course sites are nearly as redundant as the countless digital scans that would have been created of the *Mona Lisa* had ARTstor not existed. Will the image library become more and more centralized as it harnesses our collective knowledge (like Wikipedia or the Open Library)? Will the course site become a personalized "channel" created by a professor that aggregates useful content?

It is now widely accepted that digital technology challenges the authority of the instructor, the walls of the classroom, the rigidity of curriculum, and the boundaries of institutions of higher education. Perhaps, as some have suggested, we are at a tipping point which will bring us to Education 3.0, characterized by "rich, cross-institutional, ... educational opportunities within which the learners themselves play a key role as creators of knowledge artifacts that are shared." If we apply the tools listed above to higher education, is it true that we will see "the emergence of new types of organizations and institutions, which might begin competing with today's universities in any combination of higher education services, including research, teaching, and accreditation[?]" (Keats and Schmidt 2007).

Archimedes realized he had the mechanical power to move the world if only he could do the impossible and stand outside it. His was a lever that exploited the power of exteriority and singularity. In contrast, digital media's power is embedded and networked. We do not need to stand in some fictive place outside. Instead, digital technology can harness the multitude from any point within itself. Art historians should leverage existing resources to develop the specific tools we need for the study of images. To a great extent, the academy once controlled the circulation of reproductions of cultural monuments. That is no longer true. If we want to

engender a respect for images as more than mere illustrations that accompany text, our discipline must engage these technologies more comprehensively. This is our obligation to our discipline and to our students.

PART II

IMPROVING LEARNING

CHAPTER FOUR

BLENDING NEW LEARNING TECHNOLOGIES INTO THE TRADITIONAL ART HISTORY LECTURE COURSE

LAETITIA LA FOLLETTE

Much recent scholarship on teaching (including some in this book) suggests that traditional approaches, especially the dual projection art history lecture, are better thrown out in favor of new technological tools and more interactive approaches.[1] But jettisoning the art history lecture is neither always possible, nor desirable. This essay presents a case study where traditional art history slide lectures in the classroom were supplemented with web-based tutorials as homework to help students develop important skills for success in the introductory survey. The positive data from this ongoing experiment suggests that adaptation can be as beneficial as radical change.[2]

At the University of Massachusetts Amherst, my colleagues and I teach nearly a thousand undergraduates each year in introductory art history surveys that are (still) lecture-driven. These are highly successful

[1] For example, Phelan et al, 2005, esp. 37 and 39 and Bersson 2006.

[2] This essay draws on material from several conference papers over the last five years, including La Follette 2003, La Follette and Peterfreund 2006 and 2002. I wish to thank Marilyn A. Lavin, Dana Leibsohn, David A. Levine, Andrea Pappas, Alan Peterfreund and George Ryan for their careful reading and helpful comments. For stimulating collaboration and good humor, I am grateful to a number of other colleagues, both on and off campus. Walter Denny and Anne Mochon worked with me on this project since its inception. Gretchen Fox stepped in at a critical moment. Computer wizards David Hart, Matthew Mattingly and Cindy Stein have helped in more ways than I can list here. I would also like to thank John Pemberton III (Amherst College,) Larry Smith (Holyoke Community College) and Victoria Weston (University of Massachusetts Boston). The combined expertise of all and their willingness to experiment provided the foundation material for this essay.

courses: semester after semester some 75% of the student respondents rate them as excellent or very good. Those numbers, and the perception that the students at our large public institution are representative of their peers across the nation, explain why our faculty is so often asked to review and contribute to art history textbooks.

This essay examines the factors that prompted us to consider new ways of learning besides the traditional lecture, and then analyzes the process of developing new materials, critical factors for the successful redesign, our project's results and what we see as important next steps.

Context

At the University of Massachusetts Amherst, undergraduates are required to fulfill General Education requirements through large enrollment classes such as one of the three introductory surveys of the History of Art. [3] Like most of my contemporaries, I had no experience either lecturing to large audiences or supervising graduate student assistants when I was hired. I knew what subject matter I was to cover, but not what students should learn. Figuring out how to pace myself, how many objects to illustrate, which examples to choose, and how many themes to develop over a fifty-minute period were all new and important lessons, inculcated by doing as well as listening to my colleagues. I came to understand that good art history lectures involve more than entertaining stories (though they can help.) Good lecturers motivate students, engaging them with the art. They also show students how to look, that is, how to tease out clues to an interpretation from what one sees. Everyone has eyes, but few know how to look carefully, or to build a hypothesis based on what they observe. Much of what we try to teach students at the introductory level involves visual analysis. Discovering visual structure within the work through visual or formal analysis requires developing a good eye for style, iconography and composition, as well as the ability to order one's findings in a clear and logical way. [4] A good lecture models all of these.

[3] Two of the three courses employ teaching assistants to lead weekly discussion sections; the third, offered twice a year, has graders only. All three enroll 200 or more students per semester, for a combined total of 800 to 1000 students a year.

[4] This is not an exhaustive list of learning objectives. For more, both at the novice level and for more advanced students, please see Appendix I.

Needs; preliminary experiments (aims, funding, focus)

Tenure and classroom experience brought the luxury to experiment with ways to enliven the lecture format with more active learning, and to explore broadening the horizons of the survey beyond Europe and the U.S. Both were popular themes in educational circles by the early nineties, but successful models were harder to find. Release from a course's teaching duties as part of a fellowship from the University's Center for Teaching was critical, because it gave me time to think about some of the limits of the large surveys from a student's perspective, and how various technologies might provide solutions.

I was first attracted by the potential of technology to expand the parameters of our team-taught and largely western-focused survey which featured Islamic art, but no other non-western material. Why not tap the expertise of colleagues at other institutions who specialized in the areas of nonwestern art we wanted to present to our students? They could partner with us to produce short introductory presentations, accessible via computer, to allow students to compare and contrast examples of nonwestern art to the development of art and architecture in Western Europe covered in lecture. Visual exploration would be enhanced thanks to the high resolution images, much easier to examine carefully on the computer screen than was possible in lecture or textbook, while the compelling combination of image and soundtrack, the voiceover of the expert who served as personal guide, would further engage the students.

The success of an initial pilot led to a substantial grant from FIPSE (U.S. Department of Education) to develop a more extensive series of case-study modules on western and non-western art, as a prototype e-text on CD-ROM.[5]

As work on the CD-ROM progressed, other needs became apparent: accountability (how to ascertain the students were using what we gave them, and what they were learning,) integration (how best to weave new materials into existing courses,) identifying key skills (how to make more explicit the skills we wanted students to learn,) and practice (namely low-stakes opportunities for the students to practice what they learned at their own pace, without fear of grade or an audience that might intimidate them.)

[5] "A History of Art for the Twenty-first Century" funded by the U.S. Dept. of Education/Fund for the Improvement of Post-Secondary Education [FIPSE] grant P116B980674 1998-2002.

The E-case studies: initial design, implementation, pedagogy, problems (1998-2001)

The FIPSE project aimed to develop eight multimedia modules for initial testing by students in the large enrollment surveys at the University of Massachusetts Amherst (AH 100 and 110), and then disseminate the prototype to several other institutions with different student profiles (Stonehill College, Holyoke Community College and UMass Lowell.)[6]

The first two years of the project were focused on module production and testing at the University of Massachusetts Amherst. Very little multimedia had been used in any of the survey courses at the University prior to the FIPSE project. Challenges included logistics and infrastructure problems (particularly student access to campus computer labs), the costs of procuring image permissions, and determining how to integrate the new with established pedagogy.

The initial design resembled a slide show with high quality images to allow students to look closely, paired with a guiding narrative by a faculty expert. Topics for each module were chosen to coordinate with art historical curriculum in the surveys and specific content matched to the expertise of available faculty authors. Pedagogically, these modules aimed to teach students how to look, and what to look at, but they were still based on the lecture and the paradigm of information transfer. The author showed and told. The students read and/or listened. As in the earlier pilot, students could control the speed and sequence of parts of the lecture, but interactivity was minimal.

Feedback

Students appreciated the new approach, but were used to greater interactivity from a computer-based application. They were also savvy about the relative status of the modules, treated as experimental add-ons. Whenever these were not covered on a test, students became casual about using them. Faculty reaction to the modules ranged from the categorical refusal to countenance a computer-based approach to learning, to willingness to experiment with them as add-ons without integrating them

[6] Modules developed were Learning to Look at Painting, Perspective, Chinese Landscape Painting, Gelede (African) Headdresses, Picasso and Primitivism, Sacred Space: the Greek Temple, Sacred Space: the early Christian basilica, and Sacred Space: the Dome of the Rock.

into the curriculum.[7] The project team itself (faculty authors working with a couple of student programmers) focused on producing the modules on deadline, with subsequent loss of perspective and attention to learning goals. The Advisory Board for the project, which met annually, tended to be hypercritical of content, so its meetings focused largely on picayune details of the individual modules. Early efforts at evaluation and assessment were similarly unproductive, because we had not articulated our pedagogical goals.[8]

The third year of the grant called for dissemination and refinement. Dissemination occurred at two of the three schools targeted (Stonehill and Holyoke Community College). Our final (fourth) evaluator[9] convinced us it was time to gather better student data with surveys and interviews on each campus.

Assessment and redesign

The data collected from these surveys and interviews showed that the students on all three campuses found the modules a passive experience, that the amount of time spent on them varied too widely for faculty to rely on the material being learned, and that accessing the materials through the computer labs presented difficult problems with scheduling, location and set-up. Perhaps most importantly, students were looking for greater integration of the modules with the rest of the course: "how do they fit in?" Although there was increasing faculty acceptance of the content and production, the developing team was still more focused on these and other technical issues, instead of usage and pedagogy.

[7] Tight production schedule contributed to the lack of integration: the faculty member in charge of a course only got access to the completed module shortly before it was assigned to students.

[8] Evaluation in the first three years of the grant involved dividing the students into a computer and a control group, one of which accessed the module on computer in the lab, while the other read the module content in hard copy on library reserve. No appreciable differences were found between the outcomes of the two groups.

[9] Drs. Alan Peterfreund and Ken Rath, Peterfreund Associates of Amherst (2001 on).

In response to this feedback in the fourth year,[10] we shifted our operative paradigm, focusing more on interactive exercises than narrative content. A key element of the redesign involved partnering with professional programmers and educational software experts from the University's Center for Computer-based Instructional Technology (CCBIT).[11] This allowed the switch of medium from CD-ROM to the Web and the development of greater interactivity using the University's Online Web-based Learning software (OWL) in combination with Flash-based tutorials and multiple, multiple choice questions.[12] Web-based access made the modules available 24/7 and eliminated PC vs. Mac platform issues. Broadband access was assumed, since the image and sound files were too large for delivery over telephone lines. A few students still accessed the materials from campus or dorm labs, but this was not a problem.

Faculty authors also worked to integrate the materials into course curriculum, identifying key skills important for the survey and designing with the programmers new interactive tutorials to help students practice them. These ranged from basic skills, such as mastering vocabulary and careful looking, to more focused conceptual ones, such as understanding context; moving from vocabulary to concept; "dissecting" (reading) a painting; and relating mechanics to meaning (for examples, please see Appendix in this chapter). Students were made accountable for homework through OWL's automated grading system and course management tools which provided faculty feedback on completed homework. [13]

[10] The project focused on the UMass Amherst campus in this phase, in 2001-2002, and involved redesigning five of the earlier eight modules: Learning to Look at Painting (Mochon and La Follette), Linear Perspective (L. Smith), and the three Sacred Space modules: the Greek Temple (La Follette), the Dome of the Rock (Denny) and the Early Christian Basilica (Fox).

[11] Collaboration with this team, now part of the Center for Educational Software Development (CESD) was one of the highlights of the project, thanks especially to Dave Hart (Director,) Cindy Stein (Director of User Services) and Multimedia Programmer, Matthew Mattingly.

[12] Multiple, multiple choice questions provide a number of possible answers, several of which are correct. To get credit, the student must choose ALL the correct answers.

[13] We chose to work with the campus's OWL software because this system could be adapted for a Humanities course, even though originally developed for the sciences. Unlike similar commercial products (WebCT, Blackboard), OWL allows the integration of narratives and tutorials with questions, instead of separating out the quizzing function. Since we were developing study-aids for practice rather than quizzes, we wanted students to be able to go back and forth between the material

Evaluation

Concomitantly with the redesign, we focused on evaluation. Evaluation reflects the overall experience of a course and can be of two sorts: summative, which demonstrates the impact or outcomes associated with a particular change or intervention (our modules) and formative, which collects information to track progress as well as unanticipated consequences and take corrective action.

Surveys students completed at the beginning and end of the course forced us to look at what we delivered and how it addressed student concerns.[14] In the pre-survey, students when asked to rank those elements of the course they relied on most, cited in-class lecture, daily handouts (a sheet of guiding notes from instructor), discussion sections, textbook and written homework (such as papers). We learned that what students wanted coming into the course was to be told exactly what would be on the tests. Their approach was very facts-oriented. By the end of the course, however, they had been introduced to new paradigms (such the online homework we had developed for them) which helped them focus more on interpretation, and explaining what they saw in the works of art. These new elements now appeared in their ranking of tools for success in the class, behind the class lecture, handouts and discussion sections, but ahead of the textbook and hard-copy homework.

We also asked students to list their concerns. The students were remarkably consistent: they worried about tests. This didn't change from the pre- to post-class survey, but there were two significant differences in the other barriers they saw to their success. Writing appeared as a major consideration the students had not anticipated initially, while the rubric 'understanding lecture material' disappeared as a concern by the end of the course. The lecture was a key to their grasping important concepts and material. The diminished reliance on the textbook suggested many were reading much less: in fact, many students told us they didn't use the

presented and the questions. OWL allowed us to do this, unlike WebCT and Blackboard.

[14] We ran these surveys from 2001 to 2005 in Art History 100 (every fall) and 115 (S 2003, 2005). In the constant category over the five year period, we note that two-thirds of the students are female; a majority have not yet declared a major, though most anticipate majoring in the humanities or social sciences and fewer than 10% have ever taken art history before. Changes include an increasing proportion of freshmen and sophomores (70-80%), more art majors (and fewer art history majors), and increased experience using technology in class. Fewer students now expect an A in the class (62% versus 92% initially.)

textbook at all. Concerns about exams and written work stem from the fact that the course requires students to do a lot of critical analysis, not just to list the facts, but to synthesize, and address issues of interpretation, which is often a new kind of writing for our students.

Results

Student reaction to the redesigned online modules was more positive than before: 90% of the students used them, and spent on average nearly four hours a week on course homework, versus less than two hours/week the previous year, with few complaints. Students found the modules easy to use, a good investment of their time, and useful in helping them apply what they learned to other works. Three quarters of them found learning material from the modules more effective than from the text. They also seemed to learn more from the web-based version than the CD-Rom or text-based module. Using a common question posed on both the Fall 2000 and Fall 2001 final exams, and a controlled grading process, we found that students in Fall 2001 were more likely to incorporate correct information on 12 of the 16 measured items into their essays, suggesting the redesigned modules were more effective learning tools (see Figure 4-1).

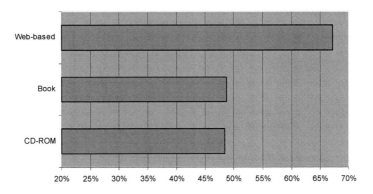

Figure 4-1: Students in the Fall of 2001 using the OWL modules, performed significantly better on the essay than the students in 2000. Using a common question, and a controlled process for grading, students in the Fall of 2001 were more likely to incorporate correct information on 12 of the 16 measured items, suggesting the revised modules were more effective at helping students learn more content-related aspects of the module. Average score of 50 essays on Dome of the Rock randomly selected from 2001 (Web-based) and 2000 (book and CD-Rom).

The two large-enrollment introductory surveys I teach now combine traditional slide-based classroom lecturing with technologically-based activities as homework outside of class. Students list the class lecture both as the most enjoyable and as the element most critical to their success in the course. So I offer both narrative lectures where learning objectives are mostly implicit, and a more student-centered, interactive set of tutorials as homework to foster the learning of skills explicitly defined. The emphasis has shifted most in the homework assignments, from an exclusive reliance on readings in the textbook to technology-based activities alongside the reading.

Students now spend more time on course homework without complaint, and find the modules easy to use as well as engaging. They are positive about the time spent and the effectiveness of these learning tools. They are also confident they can apply what they have learned to analyze other works of art and architecture. The role of the modules has thus shifted from isolated exercise intended to deliver information to a tool integral to student learning, one which fosters the development of specific skills.

Next steps

Next steps fall into two areas. The first is to continue to foster similar technologically-based approaches to learning in art history on our campus, both in the classroom (for example, with the use of student response systems); and the discussion sections, by addressing the instruction of teaching assistants and a more systematic integration of skills-based learning.

The second involves the learning objects/modules. A full complement of these (a dozen or more) could be used by interested faculty anywhere as a skills-based "lab" course for the art history survey. Successful adoption, however, will require careful consideration of learning objectives and the way the learning objects meld with other aspects of the course. Adding more modules to the current menu will require both additional resources to cover development and copyright costs (for example, partnership with a major textbook company), while dissemination will involve better communication about new learning applications in art history. The

fledgling society, Art Historians Interested in Pedagogy and Technology (AHPT), and this book, are steps in the latter direction.[15]

Appendix I: Learning objectives[16]

A) Novices (introductory survey students) should learn to:

1) discover visual structure within the work through visual or formal analysis, developing an eye for style, iconography and composition

2) order their visual findings in a clear and logical way

3) place the work of art in its cultural context, by drawing inferences from what is observed and relating those visual clues to what is known about the society, economy and culture that shaped it

4) develop a number of works of art as reference points from which to compare and contrast unknown works to attribute them to a specific time and place.

B) Upper level students (majors) should demonstrate:

5) complex reasoning, that is, the understanding of ambiguity in form and content, a challenge which requires thinking of multiple possible meanings and hypotheses to explain why an artist made the work and

6) critical distinction, learning to recognize innovation or the degree to which a work challenges convention and to evaluate various interpretations of the work by others, situating one's own interpretation and reasoning in relation to these.

Appendix II: examples of the redesigned application

In the module on the Greek temple (Figures 4-2a, b, and c), students are asked to learn the differences between the architectural components of the Doric and Ionic orders or styles. The standard diagrams and terms with definitions are provided, but these are programmed on the computer to

[15] As indicated in the introduction, many of the papers in this volume stem from panels sponsored by AHPT at the annual conference of the College Art Association.

[16] I am grateful to my colleagues at the University of Massachusetts Amherst and Smith College for help in defining, drafting and ordering these learning objectives.

allow students to quiz themselves matching terms, appearance and function. Once the student feels confident she has mastered the vocabulary and facts about each part, she is asked to apply that knowledge to construct a temple in either the Doric or the Ionic order, without mixing elements of the two systems. Figure 4-2 A shows how the student selects the appropriate components. Once the design is complete, a three-dimensional model of the temple, built according to the student's specifications, appears piece by piece (Figure 4-2b). If she has chosen the components correctly and consistently (either all the Doric or all the Ionic: there are two possible right answers here), the temple stands; if not, divine retribution is swift (Figure 4-2c) The object of the exercise is for the students to move from visuals and vocabulary to the concept that architectural elements belong to a larger system, and are not mere decoration.

Figure 4-2a. Building a Greek Temple: design screen © *A History of Art for the 21st Century*, L.A. La Follette.

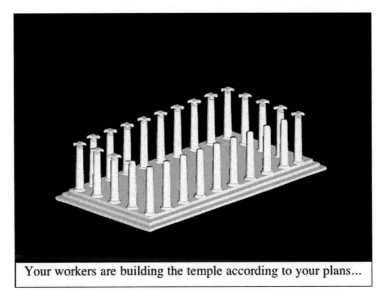

Your workers are building the temple according to your plans...

Figure 4-2b. Building a Greek Temple: construction screen © *A History of Art for the 21st Century*, L.A. La Follette.

In this exercise you will construct a Doric or an Ionic temple. Click the blue arrows to navigate through the tutorial.

try again ?

Sorry, the Greek Gods don't like it when you combine styles.

© 2002 A History of Art for the 21st Century
L. A. La Follette

Figure 4-2c. Building a Greek Temple: divine response © *A History of Art for the 21st Century*, L.A. La Follette.

Figure 4-3 shows how a similarly interactive exercise on the cone of vision helps students to grasp visually both the mathematical and proportional systems underlying linear perspective in Renaissance painting. To demonstrate the principle that the apparent size of a figure is determined by her distance from the viewer, the student is invited to move the female hiker nearer or farther from the male observer (Figure 4-3 profile view at bottom) and to measure her size at these different points with the moveable ruler (Figure 4-3, frontal view at top). To make sure the student has understood the proportional relationship, this interactive tutorial is followed by a graded question: "if a person placed 10 units away from the observer appears 6 units tall, how tall will the person appear if placed at 20 units from the viewer?" Other visual tutorials require students to find the linear armature (orthogonals) and single vanishing point in a series of Renaissance paintings, to estimate the distance of figures on that armature, given their proportional relationship to figures in the foreground, and to think about the metaphorical significance of the placement of the vanishing point. These examples illustrate the way technological applications can help students understand how a work is structured and how that structure conveys meaning.

Figure 4-3. Interactive tutorial on proportional and mathematical system of linear perspective © *A History of Art for the 21st Century,* L.A. La Follette.

CHAPTER FIVE

PURSUING THE FULL POTENTIAL OF DIGITAL TECHNOLOGY FOR ART & ARCHITECTURAL HISTORY: THE VISUAL MEDIA CENTER AT COLUMBIA UNIVERSITY

ROBERT CARLUCCI, ALEXANDER HAUBOLD, AND JEREMY STYNES

> The machine is always social before it is technical. There is always a social machine which selects or assigns technical elements used
> —Deleuze 1977, 126-7

Columbia University was an early adopter of a campus-wide digital strategy to impact teaching and learning.[1] Columbia units such as the Center for New Media Teaching and Learning (CCNMTL) and Digital Knowledge Ventures (DKV) developed and integrated a variety of digital resources into the curriculum based on direct interaction with faculty. Usually these new media resources are e-seminars, carefully structured programs combining text, images, animations, video, and audio to create multi-media learning environments. Recently Columbia University Libraries incorporated CCNMTL and DKV under its administration, signaling a maturing of digital learning resources managed, in part, by the Office of Digital Libraries Programs. From the start, these initiatives were intended to foster an atmosphere of experimentation to inspire faculty and staff to venture boldly into the e-classroom.

[1] We would like to thank the following people who contributed to the success of the Visual Media Center: Barbara Ashbrook, Hilary Ballon, Yung-yi Chou, James Conlon, Michael Crow, Deb Howes, Maurice S. Luker, III, Max Marmor, Pilar Peters, David Rosand, Andrew Tallon, and especially Stephen Murray, the founder of the original Media Center for Art History, Archaeology and Historic Preservation at Columbia.

In art history, however, the path to a digital future was not easily paved. The teaching of art history presented a set of unique challenges on both the technological and philosophical fronts requiring deft solutions and a surfeit of enthusiasm. This paper is a recounting of the strategy that proved successful in cultivating the transition to digital teaching in the Department of Art History and Archaeology and the emergence of educational technology as an indispensable partner in instruction and research.

At Columbia, the move toward digital teaching in art history began in the mid-1990s with a start-up Media Center that would eventually subsume the slide library and is now the principal center of programmatic development for digital resources devoted to the fine arts, architectural history and archaeology. The Visual Media Center (VMC) was founded as the Media Center for Art History, Archaeology and Historic Preservation by Stephen Murray in 1995 and under the guidance of the University administration won a National Endowment for the Humanities Challenge Grant. Shortly thereafter, the Andrew W. Mellon Foundation awarded a grant to support new media curriculum development. In 2001, the NEH Division of Education awarded the Media Center a multi-year grant for a project to develop digital teaching resources for architectural history. In 2003, the Media Center for Art History was merged with the traditional Visual Resources Collection (slides and photographs), rechristened the VMC, and charged with the complete transition to digital teaching for the department. In 2004, the VMC won a second NEH grant to create digital teaching materials for the history of Asian art. In addition to the generous grants from the NEH, the VMC also received major funding from the National Science Foundation, the Samuel H. Kress Foundation and the World Monuments Fund.

Pursuing grant-funded projects representing the viability of the VMC would have been unthinkable if the center did not succeed in its core mission to integrate digital teaching into the daily lives of the art history faculty. To meet this challenge, the VMC staff developed a stealth strategy to launch digital teaching using locally developed solutions. Local development was critical to give an informed staff the opportunity to develop a system that was adaptable and scalable, allowing us to react to increased demand in a timely, sensible manner. Funding was available through the Office of the Executive Vice President, but it was crucial to keep costs within the customary budget framework to demonstrate long-term viability.

Prototype to Infrastructure

From the inception of the VMC, a guiding principle of its efforts was the development of new media resources for Masterpieces of Western Art, popularly known as Art Humanities, part of the Columbia College core curriculum. With an annual enrollment of 1,200 students and taught by 30 instructors, Art Humanities offered a promising arena for introducing new media to a wide audience of stakeholders. The syllabus includes major monuments such as the Parthenon and Amiens Cathedral, and works by Raphael, Rembrandt, and Monet, thus providing exceptional circumstances to create digital examples relevant to a wide swath of art history teaching.[2] Further, a digital Art Humanities presented as a prototype alternative to slides offered the occasion to impact teaching practices throughout the department.

Beginning in 1996, the VMC was producing Art Humanities instructional videos dedicated to Amiens Cathedral and Raphael's Stanza della Segnatura in the Vatican Palace under the direction of two senior scholars, Stephen Murray and David Rosand.[3] Each video featured two- and three-dimensional animations illustrating didactic points emphasized in the course. Although Art Humanities faculty adopted the videos for classroom viewing, the projects were labor intensive requiring a substantial investment of time and effort on the part of faculty who acted as film directors and producers as well as scholars and teachers. For these reasons, other faculty members were reluctant to direct additional Art Humanities projects despite expressing an interest in new teaching materials. What seemed like a promising start for a long-term digital strategy was, in fact, not drawing in crowds of enthusiastic faculty.

In assessing a course of action to promote a digital Art Humanities and, by extension, demonstrating an attractive model for the entire art history curriculum, it became clear that the next step lay not in further production of high-end materials but rather communal distribution of basic visual resources via an online database that supplanted the 1,500 slides

[2] The syllabus includes the Parthenon, Amiens Cathedral, Raphael, Michelangelo, Bernini, Pieter Bruegel, Rembrandt, Goya, Monet, Picasso, Frank Lloyd Wright, Le Corbusier, Jackson Pollock and Andy Warhol

[3] Amiens Cathedral, Parts I and II: Stephen Murray, Maurice S. Luker, III, Scott Sindorf, Meredith Cohen, funded by the NEH and The Office of the Executive Vice-President, Columbia University. Raphael I, The Disputa, and Raphael II: The School of Athens: David Rosand, Maurice S. Luker, III, Scott Sindorf, Andrew Tallon, Jennifer Jones, funded by NEH, The Gladys Krieble Delmas Foundation, The Office of the Executive Vice-President, Columbia University.

forming the core set of teaching materials. This strategy was adopted in the fall of 1999 with little fanfare but with the implicit goal that a digital Art Humanities would serve as the testing ground for the deployment of a departmental image database to replace analog slides.[4]

In the fall of 2000, the VMC launched the Art Humanities image database embedded in a Web site intended as the online portal for students. This new system was programmed by an undergraduate student in the Department of Computer Science as part of a three-member team: database developer, educational technologist and project manager. This small team faced several challenges. Limited funding required the use of non-commercial software for the database program. Not only was cost an issue for the experimental project, but also portability between operating systems to ensure long-term practicality: the system was set up under IRIX, transferred to Solaris, and now runs on an Apple system. We chose MySQL as a database engine, implemented all interfaces in the PERL scripting language, and deployed the Web application on Apache, while using other freely available packages for database connectivity. [5]

Developing a database that served as an art history learning tool required addressing a specialized set of technological and pedagogical issues. The Art Humanities database grew out of the need for a specific instance of a database based on pre-determined criteria specific to the syllabus, yet throughout its iterations, the database adhered to the underlying requirements established at the start of the project so the early planning stages were critical to later success. Even in its earliest phase, the idea of a single database was evolving into the concept of an application to facilitate the creation, copying and deleting of multiple databases, a programming choice that would have critical repercussions on our broader goal of migrating all art history teaching to digital. The application evolved into a fully Web-enabled database management system that connected directly to a Web interface used by students and faculty. The technical details and programming language matched the user environment while maintaining a sense of universality to serve future projects, including distribution of grant-funded materials for unrestricted access. These imperatives drove improvements and opportunities to move beyond the original Art Humanities project to encompass more courses and new media projects for future development.

[4] A prototype for a digital Art Humanities was first established in 1995 by Avery Fine Arts and Architecture Library and Columbia's Office of Academic Computing and Information Systems (ACIS) under the leadership of Angela Giral Avery Architecture and Fine Arts Library and Rob Cartolano of ACIS.
[5] Visit www.mysql.com for information on MySQL.

One of the main objectives of the project was to render the underlying technology transparent to its managers while maximizing flexibility and functionality. For this purpose the structure was modeled to match a collection of artifacts. Just as the essential items in an art collection are objects like paintings, sculptures, and architectural structures, so the database is constructed of tables containing information about these artifacts. Information related to each artifact that is either shared among several objects, e.g. creators, or that is unique to individual objects, are established in relational tables to ensure data integrity. To keep this structure transparent, we translated some of the terminology of Web forms into conceptual database objects displayed in a graphical interface. The design and management tools reflect this terminology and structure, while hiding unnecessary information. This flexible structure allowed us to extend the requisite data types to encompass any circumstance. Since the database engine is not directly visible to anyone using the system, the system can model new data types with relative ease.

In practice, the database evolved organically as this new resource took shape. The project manager combined technical skills to supervise back-end metadata development and subject-area knowledge in the fine arts. The educational technologist handled digital image production quality control as well as designing the public Web interface of the database. This customized interface presented a welcoming and purposeful space (Figure 5-1) in an environment that sensibly reinforced the structure and goals of the course so that the underlying technology was transparent in the service of the class. As a course companion tool, the database was situated at the heart of a larger Web site furnished with an assortment of higher-end programs and resources including an electronic syllabus, a collection of primary readings and, most importantly, a suite of learning tools using QuickTime Virtual Reality (QTVR), Flash animations as well as audio and video components. From the start, it was considered critical to associate the image database with advanced digital learning tools within the same space so that faculty and students could navigate among a suite of new media and grow accustomed to these learning tools at an unhurried pace.

Masterpieces of
WESTERN
ART
Humanities

PARTHENON	REMBRANDT
+ AMIENS CATHEDRAL	GOYA
RAPHAEL	MONET
MICHELANGELO	PICASSO
BRUEGEL	WRIGHT / LE CORBUSIER
BERNINI	POLLOCK / WARHOL

AMIENS CATHEDRAL

IMAGES and FILM

+ IMAGE DATABASE

- ⊡ Art Hum database images

+ QUICKTIME

- ⊡ Exterior view of west facade
- ⊡ Exterior view of central portal
- ⊡ Exterior view from clerestory
- ⊡ Interior view of nave from Labyrinth
- ⊡ Interior view of the choir
- ⊡ Interior view of south ambulatory

+ QUICKTIME CONTINUED

- ⊡ Interior view from choir triforium
- ⊡ Interior view from upper level vaults
- ▦ The Amiens Trilogy, Part 1: Reflections (large | small)
- ▦ The Amiens Trilogy, Part 2: Revelations (large | small)
- ▦ Amiens Trilogy I (4.0 MB)
- ▦ Amiens Trilogy II (4.4 MB)
- ▦ Amiens Trilogy III (7.2 MB)
- ▦ Beauvais Cathedral (large | small)

+ ZOOMIFY

- ⊡ West facade, Left Portal: Life of St. Firmin, Right Portal: Life of the Virgin
- ⊡ West facade, Central portal, Jamb figures: Apostles
- ⊡ West facade, Central Portal, Tympanum: The Last Judgment
- ⊡ West facade, Trumeau figures (St. Firmin, Christ, Virgin Mary)

TEXTS and PDFs

▦ Syllabus (72KB) ▦ Reader (299KB) ▦ Ground plan and Elevation (515KB)

SUPPLEMENTS

⊡ Animated Glossary

⊡ Amiens 360°

⊡ Explore Amiens Cathedral

Figure 5-1 Art Humanities Amiens Cathedral Menu. © Trustees of Columbia University in the City of New York.

The database was equipped with a portfolio feature allowing faculty and students to collect image sets in multiple portfolios with a range of customization options to encourage not only personalization but also to support a variety of objectives in and out of the classroom. Portfolios could be designated private, available only to the registered user who created it, or public, available to all students and faculty with access to the Web site.[6] This feature connected faculty and students to a customized Web site that went well beyond standard course management software and also superseded the library reserve shelf. Anecdotal evidence indicated students shared portfolios of study images and faculty encouraged this practice as an extension of the Socratic method of teaching practiced in the classroom. Workshops at the start of the academic year were well attended by first-time instructors keen to animate an undergraduate class and eager to use a suite of digital programs tailored to the curriculum. The learning tools taught the teachers as well as the students.

For example, an animated glossary of Amiens Cathedral (Figure 5-2) emerged as one of the most popular programs and the first digital learning tool used regularly in the classroom. Although the design echoes a book format, the functionality offers the option to click on an architectural term, such as *nave*, to see the element highlighted on a corresponding diagram or, in reverse, to click on the diagram to see the related term highlighted. An additional click reveals the definition. The choice of using either a term or the diagram to learn new vocabulary was a demonstrable improvement over the conventional labeled diagram handed out by instructors and enlivened what was previously a tedious task associated more with language instruction than art history. This modest program was pivotal in bridging the gap between digital images and new media elements for teaching art history.

The Web site operated as a seamless learning environment from the classroom to the dorm room. By 2001 the Art Humanities Web site became the preferred resource for students. Instructors were attracted by the high quality of the images which was fundamental to winning faculty endorsement. The database proved to be a robust infrastructure for the course and, by extension, for the next generation of digital infrastructure in the department. We recognized that the portfolio function was ideal for generating image pages for course Web sites thereby demonstrating the efficiency of digital technology. We replicated the system, leaving the

[6] The database is restricted to current students, faculty and staff of Columbia University.

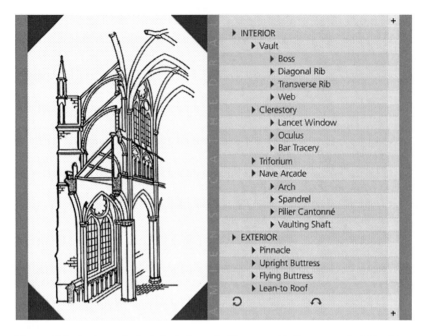

Figure 5-2 Amiens Cathedral Animated Glossary. © Trustees of Columbia University in the City of New York.

original Art Humanities database intact as one element in a growing multi-database application and developed a second iteration to serve as the departmental image database. Enhancements included improved administrator control and expanded data editing features to accommodate a growing number of student assistants. The new version of the database was titled Mnemosyne, after the mythological mother of the Muses, to identify it as *the* repository housing all materials of interest in visual culture. As an application, it is possible to continue extending this system by developing additional databases for specialized research and grant-funded projects that exist under one administrative umbrella.

The Mnemosyne database exploded from the base set of 1,500 Art Humanities images to more than 60,000 images in 18 months, serving not only art history but also anthropology and the School of Architecture and Historic Preservation. This number of images met a significant portion of teaching needs so the database became an inclusive resource for the entire faculty. Course Web site development accelerated beyond expectation and demonstrated the critical importance of digital technology in the teaching of art history. With a reliable repository populated swiftly by staff

comfortable with new tools and production methods, faculty embraced PowerPoint as their principal means of classroom presentation. By encouraging faculty to regard PowerPoint as essentially a blank slate for their teaching materials, including images, text, diagrams, video, sound files, and QuickTime Virtual Reality (QTVR), an atmosphere of pedagogical adventure as well as liberation emerged. What had been regarded as the inevitability of the dual-slide projector system suddenly seemed like shackles to faculty who now experimented freely with creative presentations in a manageable environment.

With energy and evidence growing in the Department of Art History, the Columbia University libraries established a Visual Resources Task Force in early 2002 with the objective of merging digital image production into a central repository.[7] Digital images were maturing and the Libraries recognized the importance of this resource in their collection development policies. The Task Force examined options for discovery and presentation software and implemented Luna Imaging's Insight as a rich package that offered a set of features to serve campus needs.[8] The VMC, although not part of the Library's administrative structure, collaborated in this initiative and was designated as the content contributor for fine arts, architecture and archaeology. Much of the material housed in the local Mnemosyne database was harvested and imported into the new Luna Insight system. The timely arrival of the University Library completed the first cycle of digital evolution from start-up renegade outpost to mature resource infrastructure. And when slide production ceased in early 2004, it was from lack of demand rather than an administrative directive.

Reaching Beyond the Digital Image

By streamlining digital production and delivering it in an attractive and effective setting, the VMC extended its reach without being overwhelmed by the quickening pace of the transition. As a result, more time and resources were available for multimedia projects that remained at the heart of the Center's mission. For example, the Amiens and Raphael video programs produced during the start-up phase were converted to digital format and became ubiquitous in the Art Humanities classroom because now the material meshed seamlessly within a suite of digital materials.

[7] The Task Forced included Patricia Renfro, Deputy Director, Columbia University Libraries, and Stephen Davis, Director, Digital Libraries Program, co-chairs, and Angela Giral, Gerald Beasely and Roberta Blitz.
[8] www.lunaimaging.com

With a project manager and educational technologist supporting faculty and a flexible database system at their disposal, multimedia projects illustrating art historical concepts flourished through the creative opportunities of new technologies. Design as an element of pedagogy became a vital component of resource development, and the role of the educational technologist in art history was defined through this process, reinforced by efficient programming and content management. This was one of the most important results of the database strategy since an educational technologist represents a new category of support staff to interact intellectually and pedagogically with faculty. Not surprisingly, new faculty viewed this staff member as essential to their teaching and in some cases critical to reviving student interest in some of the traditional art history courses for which attendance had been flagging.

Funding from The National Endowment for the Humanities, the Andrew W. Mellon Foundation and the Samuel H. Kress Foundation supported complex, multi-year projects designed to anticipate the next stage of the e-classroom for art history. The success of these grants depended on developing materials that moved beyond the individual digital image to facilitate new approaches to teaching in a wired classroom. The History of Architecture Online Teaching Project fulfilled this objective.[9] Funded by the NEH in 2001, the original conception of the project relied on replicating the textbook format in a Web environment with an emphasis on modules to replace traditional chapters. However, as the experience with Art Humanities demonstrated, instructors wanted to incorporate new media into their classes flexibly so the project morphed into a new model of resource building. QTVR, a multimedia format pioneered by Apple Computers featuring a system of panoramic capture, is particularly well-suited for architectural subjects and was evolving into a fully 360° spherical panoramic capture that has the potential to transport a medieval cathedral or a Renaissance chapel into the classroom. The VMC captured nearly 1,000 panoramas ranging from the Athenian Acropolis to Lever House on Park Avenue and, over the period of the grant, the practice of QTVR photography became a standard feature of the studio fulfilling the spirit of an NEH grant to exert a lasting impact on grant recipients at an institutional level.

The NEH grant awarded in 2004 for the Asian Art Digital Teaching Project shared with the Architectural History Project the application of digital technology to subjects that were hampered by traditional analog

[9] QTVR photographers James Conlon and Andrew Tallon, Web designer Jeremy Stynes.

formats.[10] The project depended on working in partnership with The Metropolitan Museum of Art and the National Palace Museum in Taiwan to acquire source material of paintings in their collections and, in some cases, to work with museum curators on shared teaching tools. Hand scrolls and monumental hanging scrolls that reproduced inadequately in traditional print publications were now fully accessible in a digital environment. Through the use of Flash and Zoomify technologies, the integrity of the original work was respected and the viewer, especially undergraduate students, could enter the conceptual world of Asian artists in a way unthinkable outside the museum.

As digital teaching has taken center stage in art history and allied disciplines, the focus on evolving teaching methodologies and the increasingly complex resources required to support them will become the focus of visual media centers, educational technology centers and university libraries as these units assume a leadership role. The results achieved by the Visual Media Center through its database strategy are now replicable on a national level through ARTstor, greatly enhanced by their hosting service to incorporate institutional collections, thereby augmenting ARTstor's growing collection. ARTstor's participation-based service will free many schools to explore the creative use of technology in the service of visual culture sooner than may have been expected. Funding, copyright, infrastructure, resource management, new media production and personnel training are key issues in this changing educational environment which will be addressed on the administrative level. The challenge on the organizational level will focus increasingly on the evolving relationship between faculty and the new categories of support staff who must work in partnership to achieve meaningful results in the e-classroom, especially in an environment where support personnel have ever more sophisticated skills and educational backgrounds. A requirement of the NEH and often other funding agencies is that Web-based materials are made publicly available for the benefit of the entire educational community. This stipulation requires cooperation between faculty, staff and outside cultural institutions to leverage expertise, experiences and resources to take advantage of the opportunities in a digital academic world. One of the most promising avenues of cooperation now emerging is the migration to the Web of scholarly publications in the arts and architectural history, creating opportunities where faculty research, educational resources and

[10] Web designer Yung-yi Chou. We would like to thank Roberta Martin of Columbia University for participating in this project.

sophisticated digital technologies may merge for the benefit of the entire academic community, from undergraduate students to senior scholars.[11]

But there is an irony in executing a successful digital image strategy that may lead to the elimination of traditional Visual Resource Collections now that the physical demands of slide and photograph collections are drawing to a close. Visual resources curators must emphasize targeted collection development and reference services to meet the emerging needs of digital teaching and research. They must work in tandem with educational technologists to support programmatic projects. To ensure not just the continuation of visual resource facilities, but their evolution in a new era, it is necessary to reinvent their purpose. A Visual Media Center should be a vital component of fine arts departments, institutional libraries, and instructional technology centers because it offers an indispensable resource for any area of the humanities where visual culture is essential to the educational experience.

[11] Hilary Ballon and Mariet Westermanns, Art History and Its Publications in the Electronic Age, funded by the Andrew W. Mellon Foundation, Rice University Press and CLIR, 2007.

CHAPTER SIX

ANGEL IN THE ARCHITECTURE: COURSE MANAGEMENT SOFTWARE AND COLLABORATIVE TEACHING

STEPHEN CARROLL, DOLORES LAGUARDIA, AND ANDREA PAPPAS

In retrospect, it seems like common sense. Art history professors often bemoan the quality of students' papers, yet class time is too precious to spend working on writing, and in any case they aren't trained to teach writing. Composition teachers commonly wish that they could spend more time working on writing, but good writing depends on well-developed ideas, so significant class time has to be spent discussing those ideas. If we connected the courses, students could develop paper topics and discuss ideas in their art history class then extend and refine those ideas through intensive focus on writing in their composition class. This would allow teachers in both courses to spend more time on what they are trained to teach, improve students' writing, and deepen learning in both disciplines. These were our goals when we began our project. We did not expect technology to play an important role in our project, but a seemingly minor administrative decision transformed our teaching in ways that were not only central to our success, but showed us that these goals merely scratch the surface of what is possible.

The Project and its Goals

Our project arose from a student comment. Carroll overheard a Santa Clara University junior say to a first-year student, "You know, of course, that everything you've learned in this class applies only to English classes. Only an idiot would write this way in another class." This led to conversations about students' tendency to compartmentalize what they

learn, about how traditional ways of designing and teaching courses encourage this tendency, and about how students might apply the skills and concepts they acquire more holistically.

We thought that linking an art history course to a writing course would increase students' ability to think across disciplinary boundaries and help them see how applying concepts and skills they learn in one class (especially writing classes) to other disciplines could help them learn. Our primary goal was to accelerate and deepen students' learning. Current research suggests that learning consists of creating connections—neurological and metaphorical—that organize information into meaningful, retrievable patterns (Bradford 2000; Zull 2002; Lakoff and Johnson 1980). Asking students to think about how the things they were learning in their classes are related, we theorized, would help students create more—and more diverse—connections between ideas and disciplines. This would enhance their learning by helping them build more inclusive, more meaningful patterns, more quickly. Research also suggests that students only retain what they learn if they integrate it into recurring practices; connections fade if they don't get reinforced regularly. Likewise, learning only lasts if it gets meaningfully integrated into students' practices (Mentkowski 2000; Zull 2002). So increasing the integration of our teaching should increase students' ability to use and retain what they learned. Asking students to consciously integrate their learning across two classes should also help them become more intentional in the ways they learn—which research tells us should help them learn faster, in more depth and with greater retention (Bransford 2000; Zull 2002).

These aims dovetailed with our common disciplinary goal of increasing student's interpretive prowess. Introductory art history and writing courses often focus on making students more conscious of the ways they interpret objects (visual and textual) by asking students to explain how concrete, observable features of the object being studied support their understanding of it. Usually, as students become more aware of their interpretive processes, their interpretations become richer, more critical and more intentional. This affects learning at every level of Bloom's taxonomy: it makes students' observations more self-aware and directed; it shows them how they can use what they already know to make sense of new situations (making them conscious of their own learning processes and how they create new knowledge); it encourages deeper analyses of objects, interpretive norms, and students' own interpretive filters; it demonstrates that synthesizing multiple interpretations increases knowledge and meaning; and it exposes the constant need for evaluation.

We thought that focusing both classes on interpretation and its connections to these trans-disciplinary modes of thinking would help students transfer what they learn across course boundaries. By showing them how to think outside of the usual boxes, we aimed to encourage more critical and creative thinking and to inculcate a habit of integrating their learning that would last throughout students' lives.

We had the usual course-specific goals. The art history curriculum required that students master a certain body of content and become proficient at visual and historical analysis. The composition courses aimed to help students more consciously develop complex purposes in their writing, become more aware of their audience, and select arguments and writing strategies appropriate to their purposes and audiences. They also sought to inculcate a habit of writing as a means of learning, using formal structures such as enthymemes[1] and outlines, constant feedback from multiple sources, and repeated revision to demonstrate to students that writing helps them discover, define, explore, change, develop and refine their ideas. We all wanted to improve students' writing (processes and products), and we wanted the arguments in their papers to become deeper and richer.

Beyond our goals for our courses and our students, we set some goals for ourselves. We wanted to learn more about what expectations were put on students in each other's fields, how to better coach students through the writing process (art history) and how to improve our individual and group pedagogy. We also strove to advance certain goals of the university: fostering writing across the curriculum, enhancing the effectiveness of the Residential Learning Communities (RLCs), and promoting faculty development at our institution.[2]

Design

We decided that the best way to achieve our goals would be to connect our courses in a way that would *show* students how to effect this transfer of

[1] The enthymeme is the most commonly used form of argument, both in writing and in everyday conversations: it consists of a statement (conclusion) with a logical reason attached to it. *Smoking cigarettes kills people because it (smoking cigarettes) causes lung cancer*, is an enthymeme. *Grades inhibit education because grades increase anxiety* is also an enthymeme.

[2] Santa Clara University's Residential Learning Communities are self-selecting cadres of students grouped according to interests. Students select a RLC during the freshman year and remain in the community throughout their time at the university.

knowledge and tools. The primary design feature and key selling point of the link was a major paper assignment each quarter that counted toward their grade in both courses. Thirty-six incoming first-year students agreed to participate in our two-quarter-long experiment. Each was enrolled in Pappas' introductory art history sequence and in one of two first-year composition courses—taught by Carroll and laGuardia. We had no TAs or graders.

The art history courses were the second and third of a three-quarter sequence covering material from about 1200-2000. They fulfill a portion of the university's Western culture requirement, so the course is already more interdisciplinary than a standard survey although it does use *Gardner's Art Through the Ages* as the backbone textbook.[3] These courses also introduce students to research tools such as the Art Index and BHA/RILA.

Composition I and II aim to increase students' proficiency with rhetorical concepts and composing processes as a way of improving critical thinking, reading, and writing. Both focus on argument: the first course teaches critical reading and rhetorical analysis of others' arguments; the second course prepares students to participate in academic discourse by teaching them to synthesize research findings, critical analysis and their own opinions into appropriately formatted original arguments. Typically, readings bearing on social or cultural issues generate conversations; students respond by writing—everything from reading-response journals to fully-developed research papers. Textual evidence provides the framework for their understanding and analysis of an issue. The linked courses added visual evidence to their toolbox: students were encouraged to apply the techniques they used to interpret a painting or piece of sculpture to a written document (poem, essay, novel, etc.) and vice-versa.

Our courses supported the link in several ways. We integrated content, focused on the same themes, and regularly connected class discussions to what was happening in the other class. We paid special attention to developing students' interpretive skills—visual and textual— in class discussions and in the paper assignments. We made the joint paper assignment the centerpiece of our activities. Each quarter, the paper assignment was scaffolded so students worked on it all quarter in both classes. Students visited a local museum, chose an object from a predetermined list, wrote a reaction paper, developed a project proposal,

[3] This book is used by the art history faculty for all their Western Culture sections.

created an annotated bibliography and wrote at least two drafts before submitting their final paper.

In addition to the common assignment and common texts, we developed a common vocabulary for discussing writing and learning. The enthymeme provided the foundation for this vocabulary and served as our fundamental pedagogical tool. Although our pedagogies differed in other areas, as did some of the course material and assignments, the focus on the enthymeme helped create a common set of expectations and helped us execute our shared pedagogical goals

We used Santa Clara University's standard course management system—Angel—to support the link.[4] Our decision was initially motivated by a desire to save paper and reduce administrative overhead, but we also thought it might help us share class resources. Angel is very easy to use and can enhance instruction without becoming part of its focus. We posted all our course materials and used Angel's monitoring features to see who read what and when. We required students to submit assignments via Angel's drop-boxes. This allowed peer reviews of paper drafts and facilitated simultaneous grading, allowing us to return papers to students with comments from both instructors in less than a week. We set access rights to allow each of us to see everything posted in all three courses, including each other's comments on students' work. Using Angel in these simple ways transformed communication among students and teachers, reshaping learning outcomes at all levels.

What Really Happened: Process

Access to each other's course materials and teaching processes created a virtual desk that we all shared. This dramatically changed the way we communicated: seeing each other's pedagogy in detail helped us understand what and how the others were teaching in a way not accessible through workshops or classroom visits. We communicated not only through our classroom materials, but also through our comments on students' work. Both helped us understand what we each were trying to accomplish. This helped break down *our* compartmentalization of knowledge and helped us develop the common language and coherent processes we needed to convince students this was a unified educational experience, rather than two classes that shared some readings and an assignment. Because we could see what the other teachers were telling our

[4] The Angel Learning Management Suite is described and demonstrated at http://angellearning.com/products/lms/default.html.

students, we could coordinate our instruction, helping students see how the issues they were working on in the other class applied to our own class and vice-versa. This multiplied opportunities for students to make meaningful connections, integrated their learning, and helped them learn faster in both classes.

At every level—among and between ourselves and our students—this virtual desk made our communication quicker, more complete, and more productive. When most students failed the first quiz in Pappas' art history class, for example, Carroll and laGuardia knew immediately and used the quiz to practice rhetorical analysis in their composition classes. They asked students to analyze the text of the quiz: what did the words and structures used mean? What did they imply about the author's purpose? What kinds of information did the questions ask for? What kinds of information would have to be in the answer for it to count as an answer to the question? They also asked students to analyze the relationships between their writing and their audience—in this case, Professor Pappas: what had been the primary topics covered in lectures and discussions? What were the primary components of those topics? Wouldn't they expect that most of the questions would be about these primary topics and their components? These conversations helped us discover that despite the abysmal scores (32 out of 36 students earned failing grades, and many scored fewer than 10% of the available points) most students understood humanism (the subject of the quiz) and its indicators reasonably well. This discovery helped us reject the obvious assumption about why the grades were so bad—the students hadn't studied—and focus instead on the more complex real reasons for the bad grades: students didn't know how to study for quizzes, how to interpret the questions, or how to write answers that would connect their understanding of the material to the questions.

Communicating this discovery to Pappas led us devise a teaching plan that addressed the root problems. All three of us spent portions of our next class sessions teaching students how to take notes in lecture and when they read, to read for retention, to listen actively to a lecture, to sort information for what is most important, and to record it in ways that promote understanding and retention. We also spent class time analyzing the questions to bring out their rhetorical features and show students how their interpretations of the questions shaped the kinds of answers they gave. Creating these obviously beneficial connections between what we were doing in English classes and how students were performing in their Art History class reinforced the idea that what they were learning transcended disciplines and could be applied to any class and to all fields of academic study—not just writing or art history. Such spontaneous coordinations

allowed us to emphasize the coherence of the scholarly enterprise as a whole, helping students focus on common processes, not the idiosyncrasies of their professors. Crucially, because the students saw that their instructors were very different people, yet were upholding the same set of standards, the students became more conscious of their learning process. Our coordination focused students' attention on our course's learning goals, preventing them from seeing the courses as simply a series of relationships with individual instructors. Students no longer saw their classes as separate entities with separate emphases, different requirements and different standards for measuring performance. They quickly came to see that academic inquiry and the rigorous standards of interpretation in art history were very much the same as those in a composition class. This helped students understand where and how to focus their learning, made their learning more integrated, and made it more conscious.

By increasing our communication, Angel also increased communication among the students, creating a team consciousness and attitude that allowed students to create connections with each other that strengthened their learning: it encouraged them to talk to each other, to share their experiences and techniques. This made the learning done by one student available to the others—and so greatly accelerated the learning of the whole group. For instance, one student in Carroll's class discovered an interesting detail about the life of one of the artists whose work several students in both classes had selected for their final research paper. Via email and Angel's announcement function, laGuardia passed this information on to the students in her class who were researching the same topic, encouraging them to get together to explore the implications of this new information and to share their own discoveries. Most did—and the ones who did were very excited by their collaboration. The drafts of the two who didn't were significantly weaker than the others'. (One student asked if it was "fair" to share their information this way, which stimulated a discussion of the differences between plagiarism and collaboration.) Increased communication among students allowed them to integrate learning from a wider variety of sources and to take advantage of more kinds of connections. Both sped up their learning and made it richer.

Angel created a web of communication, feedback and support that allowed us to target the weaknesses of specific students and to shape and reinforce student behaviors we wanted. Our enhanced communication improved our understanding of what students were learning, allowing us to diagnose problems more quickly and accurately, and to intervene more effectively and in a more timely manner. For example, when Pappas noted that one student never spoke up in class, laGuardia took the student aside

the next day and had a conversation about the importance of class participation. laGuardia reported the substance of the conversation to Pappas, who then made it a point to call on that student in class in the next class meeting. By the end of the term, that student was participating in class on a regular basis. Without this collaboration, she would most likely not have learned how to contribute to class discussions in her first year of college. In another case, one of Carroll's students wrote an otherwise solid paper that completely misunderstood Machiavelli's intention in *The Prince*. Before speaking to the student, Carroll discussed strategies for delivering the news with Pappas. Assured that this student could handle it, Carroll chose an aggressive strategy that emphasized how utterly wrong the conclusion was and asked the student to account for the misunderstanding. After only a few leading questions, the student experienced an epiphany and subsequently wrote one of the best papers in the class. Such constant sharing of information allowed us to guide students to richer and more timely connections, accelerating and deepening their learning.

Assessment and Outcomes

We assessed our experiment directly and indirectly: using quizzes, exams, and paper assignments as well as university, departmental and custom student evaluations. Direct assessments showed that students learned a lot:

- Their interpretations became richer, more creative, more critical, more conscious.

- Their papers became longer and more sophisticated.

- Students' writing became more thoughtful and conscious. By the end, students thought of their work as building an essay, as opposed to writing out and submitting papers.

- Students at bottom and in the middle profited the most—students at the top profited the least (in that they probably would have gotten As anyway). But they, too, increased their performance capabilities, writing more thoughtful and sophisticated papers.

Indirect measurements showed the majority of students had accelerated their learning significantly, with the greatest gains in their integration of learning and ability to apply knowledge and skills from one discipline to another. Students felt they were in a better position to learn more from

their other classes. Follow-up interviews with randomly selected students a year later revealed that they felt that the linked course, although very challenging at the time, had and would continue to contribute substantially to their success in subsequent courses. Some of the conversations we began in the linked courses have been continued in subsequent classes. One student reported using both the methodology and ideas explored in the linked class in his upper-division religious studies course. Of the thirty students who participated in the linked courses for both quarters, many have kept in touch with us, and several have declared Art History or English as their majors. One student visiting laGuardia a year later said she was still using the enthymeme/to-do list structure in her upper division business courses.

We learned a lot from each other, and we became better, more effective teachers. We had to overcome disciplinary compartmentalization and ignorance, as did the students. Our openness about this and our willingness to model it helped develop strong communication skills and interdisciplinary thinking among the students, and helped everyone make more kinds of connections among the disciplines.

Recommendations

Because communication was largely responsible for the success of our experiment, we would be remiss if we didn't acknowledge the preexisting connections between us. Carroll and Pappas had known each other for a long time and had collaborated on a linked class project prior to this one. Carroll and laGuardia had collaborated on curriculum design and other projects. We communicated often, we trusted each other and we respected each other's interests and expertise. Instructors who don't know each other very well, and who wish to use a linked class model like ours, should agree to respect each other's expertise and yield decisions to the respective disciplinary expert. Otherwise they will not learn much from each other or from the linked class process.

Conclusions

Discussion of course management and other software packages designed to support teaching typically focus on the benefit to the student and the single instructor. A neglected area is instructor-to-instructor communication and how that benefits both the students and the instructors. More could be done via Angel to support this, such as utilizing the chat room and discussion thread features for the instructors, not just students.

Had we done this, we would have created records of more of our informal interactions, making it easier for us to evaluate and learn more from our process. When, as teachers, we think about communication, we habitually put emphasis on increasing communication between the students and between the students and the teacher. What we found is that the most revolutionary change was caused by increasing communication among the teachers. Angel facilitated our openness to each other as colleagues and helped us discover, share, and develop new aspects of our pedagogy.

We by and large met our original goals. We provided content for composition classes, and better writing instruction for the art history class. We helped students better integrate and retain their learning and become more conscious, more critical and more creative learners. Along the way, we too became faster, better learners—and teachers: helping students think outside disciplinary boxes helped us to teach that way.

CHAPTER SEVEN

ARTIFACT: MAPPING A GLOBAL SURVEY OF THE HISTORY OF ART

EVA R. HOFFMAN AND CHRISTINE CAVALIER

In a thought- provoking 1995 article, "Is it still possible to write a survey of art history?", James Elkins posed a challenge that more than one decade later still confronts us. Since that time, the discipline has developed a general consensus on the need to expand the canon of art history. Scholars have urged passionately that we make our survey more inclusive and open the boundaries of art history to the art of world cultures, to women, and to media that traditionally had been marginalized.[1]

Questioning whether it possible to write a survey of art history and the ensuing discussions in the professional literature acknowledge the enormous challenge and complexity of this task (Collins 1995; Cohen, et.al. 1997; Nelson 1997; Nelson 2000). For it is not simply a matter of adding, inserting and appending material to our western framework but a call to completely rethink and reorganize, in meaningful ways, the vast body of material on the art and architecture of world cultures. Furthermore, in order to achieve these laudable goals of inclusiveness, we must open up the disciplinary boundaries beyond art history into the realms of critical theory and social and cultural anthropology, among others, in order to consider global art in terms that best suit each particular subject. We can no longer pretend that an all-purpose style-driven narrative and methodology can accommodate the diversity of global art and culture, or that chronology and classification systems can simply

[1] We dedicate this article to the memory of Dr. Sally Anne Duncan. We would like to thank Laetitia La Follette and Kelly Donahue-Wallace for inviting us to present this material in the CAA session they co-chaired, *Blending New Learning Technologies into Traditional Art Historical Instruction at the Introductory Level,* at the conference of the College Art Association, in Atlanta, 2005. We thank Ashley Beer for assistance with sources for the article.

transfer from one culture to another. The implications are far reaching and herein rests the classic good news/ bad news dilemma. While it may no longer be possible to a write a unitary survey, in which all of art history is neatly contained within a single unproblemized text, it may still be possible to write histories of art.

It is no accident that following the debate over the scope and range of the survey text, a slew of articles and books appeared exploring the potential of digital technology for the teaching of art history and detailing the various pedagogical strategies in which this technology might be harnessed (Bentkowska-Kafel, Cashen, and Gardiner 2005; Cohen, et al.1997; Greenhalgh 2004; Hoffman 2000; Nelson, 2000; Promey and Stewart 1997). There may be no single solution, but we join these art historians and the other authors in this anthology in advocating that digital technology may offer useful tools through which these histories may be represented and studied.

ARTIFACT

In an effort to address the problems outlined above, in 1994, we, on behalf of the Department of Art and Art History at Tufts University, launched ARTIFACT, an interactive Web-based curriculum tool for our two-part team taught global survey course in art history, *Art, Ritual and Culture* (from 3,000 BCE to 1400 CE) and *Art, Politics and Culture* (from 1400 to the Present).[2] Committed to teaching a global and inclusive survey of art history, we turned to digital technology to enable our students to access and link images from the wide variety of historical and cultural contexts that we covered in the course, but that were not adequately available in the textbooks.

As we quickly came to realize, the digital format is the great equalizer. ARTIFACT allowed us to expand the canon and to integrate fully into our curriculum African, East Asian and Islamic, Armenian and Latin American art. Furthermore, by offering a level playing field, ARTIFACT helped to prevent the privileging of any one area over any other or the media of painting, sculpture and architecture over small scale portable arts. We can give lesser known objects the same space as the most celebrated works. In addition to its potential to accommodate an expanded and

[2] ARTIFACT is a Web application that allows Tufts University faculty and students to bring images from university, commercial, and other image databases into an array of study tools and integrate the digital works into presentation software. For a full description, see
https://wikis.uit.tufts.edu/confluence/display/UITKnowledgebase/Artifact.

inclusive curriculum, ARTIFACT is a flexible tool that allowed us to customize our course and adjust the material according to changing demands (Hoffman, 2000).

ARTIFACT's search engine allows for search by lecture number, artist, period, style and subject. Beyond the search engine, which provides students with access to the images in the database, we also designed an interactive learning environment to promote and develop critical thinking skills and explore connections and ideas across cultures through interactive pedagogical exercises including flash cards, comparisons, and an exhibition function. These allow students to generate their own visual image sequences and construct their own interpretive essays on such topics as architecture and ritual spaces, landscape, the representation of divinity, and art and propaganda.

More recently, however, changes and innovations in technology have led us to refocus our development of ARTIFACT. First, the introduction on campus of course management systems, such as Blackboard, has made it convenient for instructors to post images directly from their lectures to the Blackboard course site, independent of ARTIFACT. Furthermore, as the image floodgates have opened, a tidal wave of images has become available through ARTstor, the Internet and personal databases, far exceeding those in the ARTIFACT database. Our goal, therefore, has shifted from working within our limited cache of images to linking ARTIFACT with these extensive image databases and other material on the Web that integrate image and text. For as much as ARTIFACT pointed the way toward an expanded canon and an integrated course in global art history, the structure and database of ARTIFACT had still been guided and confined to our sequence of lectures, with the ultimate control of visual material residing in the hands of the instructors. While we were committed to using the new medium of digital technology, in many ways we still replicated the model of the "slide lecture", invented in the nineteenth century and canonized in the twentieth century (Nelson, 2000). In the context of designing an electronic library of the future, Robert Nelson warns against simply digitizing current materials (Nelson 1997). The new direction we are forging with ARTIFACT employs the theoretical model of "concept mapping," offering users/students a more open-ended, non-linear tool that can provide direct links to the wealth of possibilities on the Internet, and that the users can control themselves. At the same time, we hope to maximize the interactive possibilities of ARTIFACT through concept mapping.

Concept Mapping

A concept map is a graphic tool used to structure and represent knowledge visually. It has the capacity to explore complex material while presenting it clearly from a bird's eye view. Concept maps have been used successfully as learning tools for over thirty years in the sciences and social sciences, having been developed to study how children learn and understand science (Ausubel, Novak and Hanesian 1978; Novak 1984; Novak, 1998; Novak and Cañas 2006).

The map is constructed of concepts (ideas or objects) that are enclosed in nodes of circles or boxes and are linked together with connecting lines to form a unit called a proposition, a semantic unit, or simply a unit of meaning. A concept map usually begins in a very preliminary form and evolves through iteration. The semantic unit of linked ideas/objects represents a relationship, which is the key innovation of the concept map and the feature that distinguishes it from other systems of graphic representation. By focusing primarily on links, even more than on the individual concepts themselves, the concept map highlights the centrality of relationships between concepts located either within individual domains of knowledge or across different and more distant domains on the concept map and connected through "cross-links" (Novak and Cañas 2006). The linkage of concepts into semantic units and the potential for continuous interaction of these units along dynamic networks and pathways have been shown to lead to "meaningful learning" in contrast to "rote learning," or the memorization of a myriad of facts (Novak and Gowin 1984). In contrast to the more static model of rote learning, meaningful learning is interactive and builds upon prior knowledge. This follows research in cognitive psychology on the assimilation of new information in the brain and the creation of new knowledge. Human memory is not a single receptacle but rather a complex set of interdependent memory systems. The working memory organizes and processes all incoming information by interaction with knowledge in the long-term memory (Ausubel, Novak and Hanesian 1978).

What we suggest here is that concept mapping offers a perfect fit for the complex needs of a global survey course in art history. Concept mapping is an innately visual system that accommodates a variety of text and image based media. Furthermore, the capability of concept maps to organize and structure large volumes of material with an emphasis on effecting connections and interactions meets the considerable challenges of the art history survey course: its balance of cross-cultural study with the enormous amount of material that, indeed, can seem overwhelming.

Most of all, the concept map is a flexible tool, dependent on its context and capable of changing according to changing contexts. Its flexibility provides a strategy to present the interdisciplinary methodologies and multiple classification systems necessary to understand global culture.

Beyond its potential for organizing a global survey of art history, the opportunity for interdisciplinary and collaborative work extends to our practical implementation of concept maps in such a course. Up to this point, the research on and applications of concept maps have resided, for the most part, in the disciplines of natural and social science. Its absence from art history may be explained by the disciplinary boundaries that exist between the humanities and the sciences and social sciences. At Tufts University, concept mapping serves as a meeting point for the Departments of Art History and Academic Technology where we are engaging in a fruitful exchange of technology, pedagogy and art history. Art historians, learning specialists, and computer scientists come together to engage the language and scholarship of these varied disciplines.[3]

VUE

While concept maps existed before the advent of electronic technology, and can be drawn by hand, the electronic age has greatly enhanced their potential. Tools for the digital manipulation of graphic images have made it vastly easier to move representations of concepts or groups of concepts around the map. It is also possible to accommodate change, in data as well as unpredictable growth. Most of all, the use of electronic technology has made it possible to take full advantage of the tremendous resources of the Internet, providing links to a plethora of content, such as images, articles, web sites, or other concept maps.

The technology we are using to develop concept maps for ARTIFACT is called VUE, an acronym for Visual Understanding Environment, an information management application developed by the Department of Academic Technology at Tufts University with support of the Mellon Foundation (http://vue.uit.tufts.edu).[4] Technologically, VUE is

[3] We thank David Kahle, Director of the Department of Academic Technology and his staff for their invaluable help in the development of ARTIFACT. We especially thank those who were there from the start: David Kahle, Steve Cohen, Gina Siesling, Matthew McVey, Anoop Kumar, Ranjani Saigal.

[4] The Art History Department received an APT (Academic Partnership Grant) from the Department of Academic Technology for the academic year 2005-2006, to digitize our slide database and further develop ARTIFACT, including the integration of VUE. We would like to thank David Kahle, and Melanie St. James,

a flexible tool capable of linking a variety of digital and web resources including images and text documents, as well as links to web resources. Color and shape are used to clarify the segments explored in the map. Certain pathways within the map can be singled out for closer examination by "zooming in" or "zooming out" for a bird's eye view. It is also possible to create slide shows along selected routes of these pathways to highlight particular subjects or relationships (Figures 7-5a and 7-5b).

At its core, VUE is about sharing and collaboration. It is a free, open-source application, available for all to download and use.[5] Instructors may customize all concept links, allowing them to retain control over the choices that are selected. At the same time, VUE allows students to create concept maps, either working individually or collaboratively. The concept maps may then be disseminated and shared with other colleagues and fellow students. VUE users can create concept maps "on the fly" in the classroom, developing ideas and drawing connections to the material covered in class, in real time (Figure 7-6). Finally, VUE maps may be viewed in their own .vue format, .pdf format or saved as a .jpg or publishable web page where the links remain intact.

Examples of Concept Maps for a Global History of Art

There are a variety of possible formats for the construction of concept maps using VUE.

1. The Hierarchical Map: *The Art of Judaism, Christianity and Islam in the Mediterranean, 3rd-8th centuries CE* (Figures 7-1a and 7-1b). The most straightforward concept map format follows a hierarchical structure, where the map is constructed from top down; from the general to more specific concepts (Jonassen, 2000). The map presents individual domains of knowledge, following the familiar visual model of a flow chart. In this case, the three domains are Judaism, Christianity and Islam. In this hierarchical structure, large quantities of complex information, integrating image and text, are clearly organized and presented. The format provides students with a visual overview of the material and, at the same time, facilitates an understanding of the underlying structure of these ideas and the relationship between concepts within each segment of the map. More complex ideas and relationships are introduced through the creation of

from Tufts University, and Peter Wilkins, from MIT, for their help with VUE and for resources on concept mapping.

[5] "Open source" means the source code is not secret nor is it copyright protected. Furthermore, any user may enhance and continue to develop the application for the benefit of all users.

networks of cross-links that connect concepts across the three segments of the map, showing the interrelationship of the art of these religious groups.

2. The Semantic Network: *The Art of Judaism, Christianity and Islam in the Mediterranean, 3rd-8th centuries CE* (Figures 7-2a and 7-2b and 7-3a and 7-3b). The Semantic Network focuses more intensively on interrelationships (Jonassen 2000). The subject is set in the center of the map. The particular properties and contexts of the subject are located closest to the center, moving to the more complex global references and implications, in networks, located furthest from the center. Semantic units radiate outward from the center to the periphery for each domain of Judaism, Christianity and Islam and at the same time they circle around the subject in rings, linking concepts among the different domains. Figure 7-3 demonstrates the possibility of creating a slide show linking the works of mosaic decoration that appear in the map.

3. The Semantic Network: *The Dome of the Rock* (Figures 7-4a and 7-4b, and 7-6). The map of the *Dome of the Rock* focuses on a single monument taken from the larger semantic net of the *Art of Judaism, Christianity and Islam in the Mediterranean, 3rd-8th centuries.* The first circle around the central monument consists of its formal elements (decoration, architectural elements, and location); the second contains the functional value of these elements in the monument and parallel functions in other cultures; and the third, its broader meanings and conceptual ideas across cultures. The mapping of the *Art of Judaism, Christianity and Islam in the Mediterranean, 3rd-8th centuries* within a semantic net seen here presents a model for the study of the art of these religious and culture groups, not as separate units, but in dynamic relationship to one another, fulfilling a major goal of the global history course.

4. Student Designed Map: *The Dome of the Rock* (Figures 7-5a and 7-5b). The greatest benefit of concept maps appears when students design these maps themselves (Janasson 2000). The example here presents a strategy for brainstorming or jumpstarting a topic before the map takes shape. In this configuration, aptly termed the "parking lot," students, with or without the assistance of instructors, may gather a variety of concepts in nodes on the side of the screen (Novak and Cañas 2006). Novak and Cañas have also pointed out the value of adding a focus question. Students, working in small groups, then choose and assemble these concepts, alone or in combination with additional concepts, into their own maps. This exercise combines all of the processes of designing a concept map: identifying the key concepts, drawing relationships between the concepts to semantic units, and arranging these units visually. Students use the knowledge they already possess, and through the construction of the

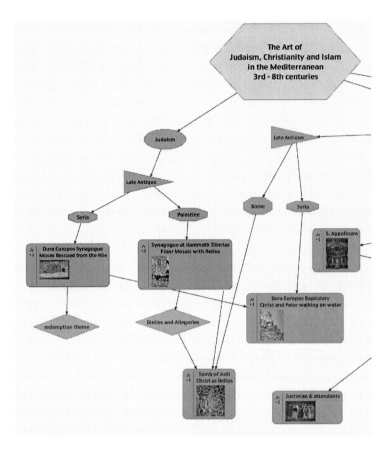

Figure 7-1a. Hierarchical Map. The Art of Judaism, Christianity and Islam in the Mediterranean, 3^{rd}-8^{th} centuries CE Left side. © Eva Hoffman and Christine Cavalier.

map they refine and expand their understanding, a technique that promotes meaningful learning (Novak and Gowin, 1984). This also illustrates how concept maps may serve as a model for active and cooperative learning.

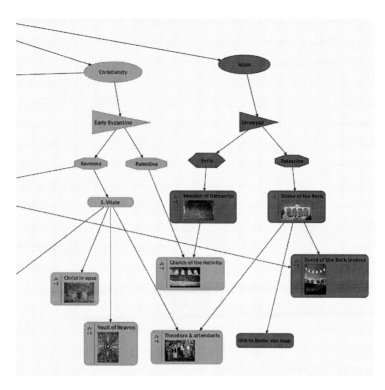

Figure 7-1b. Hierarchical Map. The Art of Judaism, Christianity and Islam in the Mediterranean, 3rd-8th centuries CE Right side. © Eva Hoffman and Christine Cavalier.

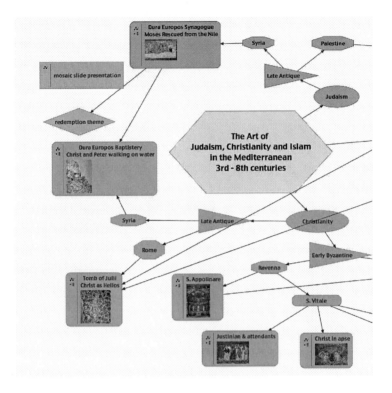

Figure 7-2a. Semantic Network. The Art of Judaism, Christianity and Islam in the Mediterranean, 3rd-8th centuries. Left side. © Eva Hoffman and Christine Cavalier.

Conclusion

In this essay we have focused on how concept maps may be used as a valuable tool in teaching a global survey of art history. By providing agency to learners, and stimulating meaningful thinking through the links between image and text, concept maps may be used efficaciously for all art history courses. Above all, however, its flexibility and context-driven nature make a concept map most appropriate for a global art history survey course. There is no single way to design a concept map. Each subject must be mapped according to its own context and function. Different people, furthermore, will construct the map in different ways, according to their own cultural outlooks, among other things. This brings us full circle to the dilemma identified at the outset of this essay with concept maps as part of

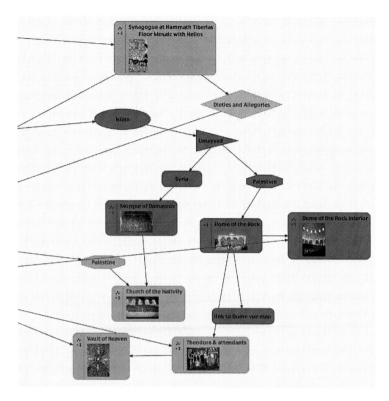

Figure 7-2b. Semantic Network. The Art of Judaism, Christianity and Islam in the Mediterranean, 3rd-8th centuries. Right side. © Eva Hoffman and Christine Cavalier.

a possible solution. Concept maps do not demand uniformity but rather allow each culture to tell its own history of art according to its own values, beliefs and hierarchies (Elkins 1995 and Cañas et al. 2005). In many ways, concept maps mirror the structure of the Web itself. Their primary function is to link ideas and information. Like the web, they have the potential for unlimited expansion of networks, and therefore, they may be continually elaborated and endlessly expanded.

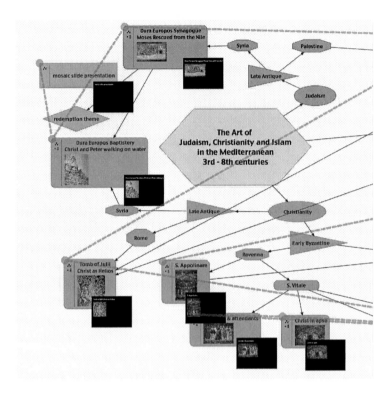

Figure 7-3a. Semantic Network. The Art of Judaism, Christianity and Islam in the Mediterranean, 3rd-8th centuries. Left side. © Eva Hoffman and Christine Cavalier.

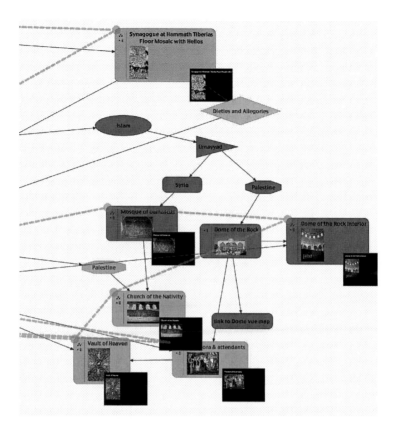

Figure 7-3b. Semantic Network. The Art of Judaism, Christianity and Islam in the Mediterranean, 3rd-8th centuries. Right side. © Eva Hoffman and Christine Cavalier.

Figure 7-4a. Semantic Network. Dome of the Rock. Left side. © Eva Hoffman and Christine Cavalier.

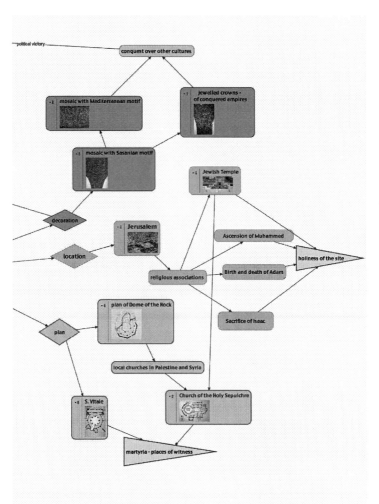

Figure 7-4b. Semantic Network. Dome of the Rock. Right side. © Eva Hoffman and Christine Cavalier.

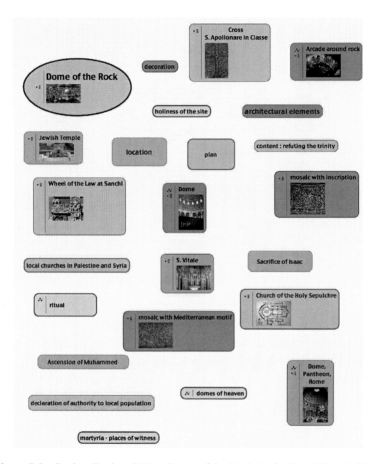

Figure 7-5a. Student Designed Map. Dome of the Rock. Left side. © Eva Hoffman and Christine Cavalier.

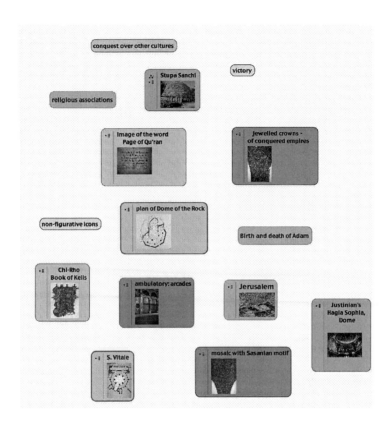

Figure 7-5b. Student Designed Map. Dome of the Rock. Right side. © Eva Hoffman and Christine Cavalier.

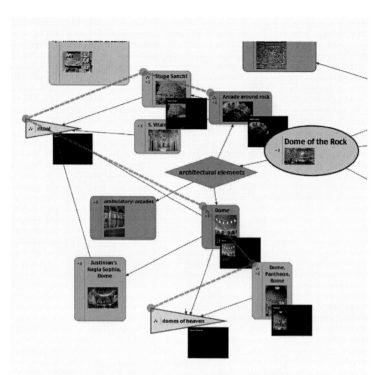

Figure 7-6. Semantic Network. Dome of the Rock. Detail. © Eva Hoffman and Christine Cavalier.

PART III

TEACHING ART HISTORY ONLINE

CHAPTER EIGHT

TRADITION AND INNOVATION: USING NEW TECHNOLOGY IN ONLINE ART HISTORY SURVEYS

EVA J. ALLEN

This essay has three purposes. First, it will address the development, funding, and delivery of an online course, *History of World Art, Part I* (ARTH 370), a 300-level art history survey at the University of Maryland University College (UMUC). Second, it will discuss the virtual classroom and offer several examples of classroom practice I have successfully employed in the course. And third, it will address some pedagogical concerns in our online course and indicate some activities that seem to remedy those concerns at least in part.

Development, Funding, and Delivery of an Online Course

UMUC is the largest public provider of *E-learning* in the nation, reaching over 153,600 in online course enrollments worldwide in 2006.[1] The University invested significantly in online delivery over the past decade, developing its own proprietary course management system (CMS) called WebTycho, a rich faculty training program in both technical and academic subjects, course delivery assistance, a virtual library with 24/7 services, an effective online writing center, and 24/7 technical help.

ARTH 370 was the first of the University's art history courses selected for online development. One challenge in constructing this course

[1] *E-learning* is used here to describe the following course delivery systems: completely online courses without any face-to-face meetings; hybrid or blended courses having face-to-face sessions plus a required number of online meetings; and Web-enhanced courses, those with selected online components as announcements, course materials, and syllabus, but not requiring students to participate in online meetings.

was conversion of the content of a traditional face-to-face course to a new format that would be congenial to learning in the Web environment. In this pursuit we observed that the Web is not just a delivery medium, but a rich resource of both textual and visual material that we can use creatively. The WebTycho platform was also integral to the construction of the course as the CMS provides the virtual structure where materials to be used by our students are situated and where class interaction takes place.

Within this framework for our virtual classroom I wanted to ensure I provided a student-centered learning environment where students became creators and interactive learners instead of merely participants in a professor-led classroom. This pedagogical strategy was most important to me as I involve my students actively in their learning experience. Active learning techniques in art history surveys have been advocated in the discipline in recent years, sometimes eschewing traditional methodology (Phelan et al. 2005).[2] The virtual environment is also congenial to problem-based learning (PBL) strategies, another teaching practice advocated in surveys of late years (Lindner 2006).[3] Throughout our course development we kept in mind that design, content, pedagogical practices, and delivery system have to work together in order to provide our students with a quality learning experience that is equal or better than what they receive in a traditional course.

UMUC uses a team approach to construct many of its online courses. Our team consisted of a Curriculum Specialist, an Instructional Designer or Project Manger, a Content Expert or faculty author (myself), a Peer Reviewer, a Senior Editor, the Programming Staff, a multimedia Graphic Designer, and the Production Staff. Development proceeded in progressive steps. At the first meeting all members were present to discuss team roles and the course scope, focus, and goals. Selection of text and other course materials were suggested, and a timeline set; format and writing standards were decided. At the next meeting, I as the author presented a course plan that included selection of the textbook, an outline of the syllabus, module

[2] Among many comments, Kathleen Desmond of Central Missouri State University spoke of her "active learning" techniques that avoid traditional classroom practices such as "compare-and-contrast methodology." Most strategies I use in my virtual classroom in fact are active learning techniques that lend themselves well to the online environment; however, I do not easily dismiss some traditional methodology either, as I shall discuss further in this essay.

[3] Lindner's problem-based learning practices in her art history surveys are similar in several respects to my own group learning activities; however, I use a different strategy to assess and grade team projects.

titles with detailed components of each, and a brief description of the projects, quizzes, and other assessment tools.

A modular format was chosen for organizing course content. The clarity and accessibility of this arrangement fit well with the complexity of the subject, World Art from rock and cave art to the Renaissance, a span from circa 40,000 BCE to 1400. Each of the five modules consisted of an overview, objectives, commentary, suggested readings, and self-assessment questions. Subsequent steps included researching and writing the commentary and other parts of the modules. This task was my responsibility, aided by periodic critiques from the peer reviewer, instructional designer, and editor. Once I made the necessary revisions, the instructional designer reviewed the final changes. Each module then went to the production staff for programming. When the last module was finished, the editor checked the complete manuscript for consistency, style, and grammar. In the final steps, the production and programming staff and the graphic designer ensured that formatting and technical guidelines were met, interactive and coding features were consistent, and that multimedia graphics and visual enhancements operated smoothly. The production staff then published the course on the Web.[4]

A typical online course at UMUC costs about $25,000 to develop, depending on the enhancements.[5] Faculty authors are paid outside of their regular duties and relinquish their rights after publishing the course, which then becomes the property of the university. Materials constructed in the conferencing area, however, are proprietary to each faculty teaching the course. Enrollment is limited to 30 students a section. Since the first offering of ARTH 370 in 2003, annual enrollments have more than tripled. The University offers multiple sections year round.

The WebTycho platform was built on the IBM's Lotus Domino software suite. This system offered the stability and flexibility the University needed from the beginning (mid 1990s) in order to deliver the functions we envisioned necessary for a successful online environment. This software has served our global students and faculty well ever since.

[4] My discussion of the development of ARTH 370 is based on the standard booklet created collaboratively by the UMUC course development staff, Associate Dean Cynthia Davis, and the Quality Matters project (Quality Matters rubric)—a statewide initiative of Maryland institutions. I thank Sharon Biederman, Director of Course Design and Development, for sharing this information and providing helpful insights, including future technical applications, in the creation of new courses. Course development procedures are under review at present in order to streamline future projects in the UMUC School of Undergraduate Studies.
[5] Sharon Biederman, discussion with the author, September, 2006.

The University is now in the process of developing the next generation platform, WebTychoNG.

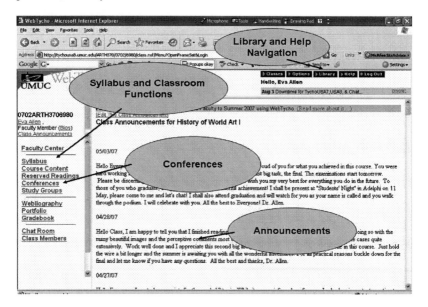

Figure 8-1. The WebTycho Virtual Classroom. © University of Maryland University College.

The virtual classroom (Figure 8-1) is constructed around an announcements area where the professor posts changes and sundry messages relating to class operation. Horizontal links at the top right provide help functions to students, including a link directly to the library. The left side of the classroom screen links to all the functional features one might expect in a traditional classroom:

- *Syllabus* details course description, introduction, course goals and objectives, grading information, project descriptions, schedule, and academic policies.

- *Course Content* houses subject matter modules. Each constitutes the lectures students access according to a weekly schedule matched with reading assignments from the text. The modules contain rich galleries of images, links to museums and archaeological Web sites, as well as scholarly texts, and mouse-over concepts. Each module has a section of suggested reading list and self-assessment test at the end of the

commentary for students to measure what they learned. A link under
Course Content connects students with the Effective Writing Center.

- *Reserved Readings* links students to Library Resources and provides a
list of e-reserves articles and essays chosen by the professor. These are
either scanned in or accessible in full text through the many online
databases to which UMUC subscribes.

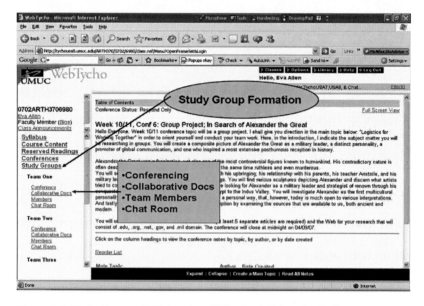

Figure 8-2. Study Groups. © University of Maryland University College.

- *Conferences* is where the class meets daily through asynchronous
discussion. The interchange takes place among students and faculty
through threaded responses to a topic or exercises posted by the professor.
A click on this link replaces the Announcements screen with the particular
conferencing discussion underway.

- *Study Groups* (Figure 8-2) allows students to be rostered into groups
for communal work and to create collaborative documents.

- *Webliography* provides an opportunity for both students and faculty to
assemble and tag important Web sites.

- *Portfolio* records the professor's interaction with the class. Student
contributions are connected not only to their *Assignment Folder*, but also to

their portfolios where every word exchanged with one another in the virtual classroom is recorded.

- *Grade Book* contains tabs for each major assignment and weekly conference assignments. Grades are entered systematically with feedback from the professor for each assignment and are computed automatically at the end of the semester.

- *Chat Room* and *Class Roster* complete the virtual classroom. The roster allows students to post biographies and upload photos either of themselves or any other choosing, and post personal Web pages. Students and faculty may communicate privately through e-mail from this port if they wish.

In my classes I use some of the old methodology that lends itself naturally to the new online technology and enhances learning for both my students and myself. The heuristic method of inquiry is basic to my pedagogical structure, encouraging students to take part actively in their learning experience and interact with their peers. Students learn best from one another so it is crucial they engage their colleagues. Assignments are problem-based and incorporate learning techniques that encourage students to think critically and work creatively with one another. My ultimate aim is that students will be inspired to visit original artworks and apply what they have learned in my online classes, visually, and intellectually.

The daily interaction in Conferences depends on threaded, asynchronous discussions among students and professor. This feature is perhaps the single most important one of the WebTycho classroom where students gather regularly for continuous exchange of ideas. I post a topic or an image, or both, for students to research and debate during a one or two-week period. I often choose an essay from the *Art Journal* or another scholarly journal. I ask students to post questions for one another based upon their readings, and thus construct their own learning material. Through this approach I hope to encourage both intellectual and visual curiosity, and have students think and look critically and thoughtfully.

The Study Groups area is another important interactive section of the virtual classroom, reserved for collaborative projects. Here students research a given topic communally and then write a collaborative document. They can supplement this paper with appropriate links, images, and multimedia applications as needed and critique, edit, and change each other's contributions.

Some Scenarios Employed in Class

The following examples will illustrate some of the strategies I use in ARTH 370. I regularly change conferences and assignment topics to keep the course vital and dynamic. I construct these assignments well ahead of time to assure availability of both textual and visual material. I still use some well-worn tools of art historical methodology and sound pedagogy that I carefully integrate with technology.

In the first example, I introduce an unidentified female image from New Kingdom Egypt. I ask students to situate the object within its own cultural context, keeping style and iconography in mind. Instead of precise identification, they observe why this image came from New Kingdom Egypt rather than another culture. They use their text to find similar images, comparing and contrasting those with the unknown image. Students conduct threaded discussions and comment on each other's findings while they sort out various hypotheses as to the origin of the given image. In the end they are encouraged to find the art object in the Louvre.

Another example involves the twins, Cleobis and Biton, a pair of Greek archaic sculptures. Students have to locate the two in a Greek mythology home page, where they learn about the legend of this heroic pair. Questions arise as to the twins' "just" or "unjust" death. Students debate the issues and research how these concepts fit in, if at all, with the moral and ethical paradigm of the Greek ideal of a hero. Students also observe the development of the archaic *kouros* and its influence from Egyptian sculpture by comparing and contrasting similar prototypes they find on the Web and in their text from both Egypt and archaic Greece. They then observe and discuss the great change that came about in 5th century BCE classical sculpture, and offer visual examples.

In a second part of this exercise, students make a virtual visit to the British Museum Web site and locate the Parthenon Marbles. After exploring the site both visually and textually, they find articles from *.edu, .net, .org, .gov,* or *.mil* domain that discuss the drawn-out repatriation issue surrounding the sculptures. Students post their findings in the classroom for everyone to critique and debate. While I give a specific topic, they actively construct their learning material from their text, the British Museum Web page, and related resources on the Web.

For a study group project I asked students to research and find various aspects that propelled landscape into a major genre during the Song Dynasty (960-1279). Each group first chose a team name from Chinese culture; they then divided tasks. Team members exchanged information

and critiqued each other's input. They made collective decisions about the quality and usefulness of contributions and choice of images; they created and edited a collaborative paper, including footnotes and bibliography. Each group uploaded their document to the main conferences area to share it with other teams and receive feedback. After peer review, I made my comments to each group.

A major individual assignment involved a formal research paper that helped students develop critical thinking and problem solving skills by becoming acquainted with an important issue that had broader ramifications for society at large outside of the art world. Students analyzed an essay from the *Art Bulletin* that they located in full-text format, using some of the many online databases available through the library. For example, I included an essay on the Bamiyan Buddhas and the First Emperor's army. Students posted their completed assignments in their assignment folder for my reading, assessment, and individual feedback.

Finally, I end the semester with an exercise that calls upon students' visual perception skills by looking at beautiful images and selecting art objects for a hypothetical exhibition catalogue. They choose five art objects from different cultures and media. Students start with an introduction, then prepare separate entries, keeping style and iconography in mind. Their own assessment of why they selected each art object is an important part of the entries.

Problems in the Virtual Classroom and Some Strategies that Work

Several issues arise in the virtual classroom that must be addressed, although they are not necessarily specific to online delivery. The first is the retention problem. How do we reach out to those students who come to our classes with less motivation than others? One strategy I have used successfully is to give learning tasks based on interdisciplinary activity. Students like to discover common denominators among disciplines and make links on their own that prompt them to share what they already know. In turn, their peers' attention is aroused and a stream of questions and interaction can result.

I also capitalize on our global, multicultural student body. I encourage input from students coming from different corners of the world and ask them to talk about their country's art and their own experience with it. I tap students' photo reservoirs which they acquired *in situ* and usually are as good as any on Flickr. I ask my students to tell us in class when they visit

a museum, a community gallery, or anyplace where they encounter art. Not all, but some return repeatedly with their own experiences. I call their attention to my museum visits and advise them about ongoing exhibitions.[6] I also post topics that intersect with students' daily lives to which they can relate from personal experience. These activities, among others, make the class more varied and interesting so most everyone finds a reason to stay until the end of the semester.

Another concern in my online classes is the issue of information literacy. As the Web has become a ubiquitous source of information, the need for "librarians, faculty, administrators, and technical experts" to collaborate in building meaningful information literacy into curricula has grown in importance (Barbour et al. 2004, 2-3). We need to help students develop "cognitive skills (information competencies) [that] engage students in a higher-level thinking and problem solving skills." These skills will enable them to become competent researchers, evaluators, and communicators of Web resources. This outcome is perhaps even more critical in the online environment than in a face-to-face class because the Web is there with instantaneous material, just a click away. Indeed, some available sources are good, scholarly material; however, the opposite is also true. Many students go out on the Web and use sites that are clearly unacceptable for academic purposes; some are just patently naïve about it, while others just look for a quick fix.

To help students discriminate among the resources they use from the Web, I have integrated library resources actively in my ARTH 370. We do have a 24/7 "ask a librarian feature;" however, I want to make certain that this resource does not sit there passively. In this endeavor I collaborate with online librarians who come into my classes and address various issues. The library session is one week of a three week group project. I choose a specific subject for the group project which gives the basis for the library work.

Evaluating Internet Resources deals extensively with domain issues. Students take a quiz with concrete examples and scenarios to analyze. Librarians give feedback to every student, explaining each missed answer. The group activity continues by each team for another two weeks resulting

[6] A good example of this kind of inclusion is the exhibition, *Treasures from the Royal Tombs of Ur*, that traveled for years in the US. In October 2006, one of my students drove from Manhattan to Middlebury College, Vermont, after hearing from me about the show in late September. She came back with a most enthusiastic and discerning report, telling the class in detail what she saw. Her visit generated a lively interchange at the space we called "Commons" in the WebTycho Conferences area.

in collaborative papers. The librarians assist me in assessing the final documents to see how well students utilized the lessons learned during the library session.

Visual literacy is a third thorny issue I encounter. Bamford (n.d.) advocates a complex, structured approach that rests in part on well-tried art historical methodology. Mirzoeff (1999, 6-7) proposes that a structured way of learning to look is not compatible with our contemporary everyday visual culture, arguing that "most of our visual experience takes place aside from these [movie, television, art exhibition] formally structured moments of looking." My experience has been that many students come to art history surveys wanting to master some sort of formal tools to help them observe art objects. Thus I feel art historians should find ways to teach their students to look, and acquaint them with the complex nature of seeing. If we are successful, our students will be able to better discriminate and apply these skills in the broader visual culture of their everyday lives.

Visual literacy can be approached by having students see many beautiful images. Students learn first to identify them. While I do not require wholesale memorization, I do ask my students to identify key artworks. I speak to them about style and iconography and introduce them to Erwin Panofsky's iconology on a palatable level with various examples. Students learn about the images, situate them in their cultural context, analyze them stylistically, and understand their metaphorical relevance. I want my students leave my classes with a handful of images that will be always meaningful to them, not just because they recognize them visually, but because they know what is behind those artworks.

Apart from the more structured way of exploring how to look at ort objects, I also introduce my students to James Elkins' *The Object Stares Back*, a perceptive analysis of the physiological, psychological, emotional, and cognitive aspects of how we take in the visual world around us. The author situates his observations within a broader spectrum of diverse experiences, not just specific to viewing art objects in a controlled setting. Elkins ends his first chapter of "Just Looking" with the discerning idea of deep seeing that is achieved by breaking down the barrier between observer and observed. Once we are at that point, the "betweenness," as he calls it, viz., the unity, is established, meaning: "...part of me is the object, and part of the object is me." (Elkins 1996, 44) In addition, I bring to my students Malcolm Gladwell's *Blink*, a fascinating, pragmatic account of what are the conditions of a "single glance" that can be as meaningful as extensive research or study assessing visual phenomena or various everyday situations. (Gladwell 2005, 8) His starting point is the infamous case of the Getty *kouros*, an apropos example for art history students.

Assessment of student work is an often problematic aspect in education, not only in online course delivery but in the traditional classroom. Having taught in both, I have concluded that I have more comprehensive assessment information about each of my student's work in the online class than I had in my face-to-face classes. In a typical face-to-face survey with 100 or more students, the professor hardly engages every learner. In an online course with no more than thirty students, the situation is much different. Students sign on several times a week and some are in the virtual classroom every day. They go well beyond the required number of responses and interaction with their peers. I evaluate conferences for both form and content, and give feedback regularly to each student after a topic closes.

The collaborative aspect of group projects brings an added complexity. I have devised a system that keeps in mind individual input and participation as well as collaborative work. Thus students know they are personally responsible for the work they contribute within the broad communal framework and do not just rely on someone else's efforts. They also understand their commitment to their peers and are less apt to let them down.

A Final Comment

Technical innovations are exciting achievements; their creative use in higher education represents a promising intersection of entrepreneurship, human ingenuity, creativity, and thought. We need not only to keep abreast with developing technical advances, but rather to anticipate them in our academic institutions. However, we also need to keep in mind that we are educators and art historians. Zimmerman (2002, xiii) cautions us that "Art history for you, is also what it *happens* to be for you: your tradition, your education, your institutional practice. And it is what you feel you *must* do with it and within it." We would do well to remember this advice.

Our responses to the challenges that new technology offers and the tools we acquire and use should not just be dictated by the drive to use technology because it is there. Rather we must carefully evaluate how our discipline can receive those tools and fit their use to our pedagogical needs for the greatest benefit of our students.

CHAPTER NINE

A TALE OF TWO COURSES: INSTRUCTOR-DRIVEN AND STUDENT-CENTERED APPROACHES TO ONLINE ART HISTORY INSTRUCTION

KELLY DONAHUE-WALLACE

The following paragraphs summarize the creation and technology-mediated pedagogy of two online art history courses. The essay reviews the funding sources and labor distribution of their development, the tools employed in each, and a summary of course operations. More importantly, the essay compares the courses' pedagogy and exploitation of technology. Its purpose is to provide a critical evaluation of models of online teaching.

Lectures in Cyberspace

ART1300: Art Appreciation is a global, thematic introduction to visual art at the University of North Texas. The course addresses two- and three-dimensional media followed by architecture, weaving formal elements and principles of design in these media-based units. The bulk of the course explores why humans have made art, embracing a broad definition of art more akin to visual culture than "high" art. These thematic sections address survival, religion, identity, politics, and defining the artist. The goal of the course is to help students to grasp how humans have used art to understand and engage their world. The course serves the breadth of UNT's undergraduate student body; most of its 300 (in 2003, now 500) students each semester are 18- to 25-year-olds who take the online course even though they live on campus or in the surrounding area. Five teaching assistants help the instructor with grading and course management.

ART1300: Art Appreciation became my first experience authoring distance learning content when the State of Texas and the University of

North Texas offered me a $20,000 Telecommunications Infrastructure Fund (TIF) grant for online course development. UNT is a pioneer in online instruction, committed to giving ample financial and staffing resources to faculty to produce exemplary distance education. Development grants encourage tenured and tenure-track faculty participation. So too do the school's intellectual property contracts that in most cases allow both the faculty member and the university to share rights to the course content.[1] The staff of the Center for Distributed Learning (CDL) rounds out the resources. Instructors are partnered with CDL's instructional designers, multimedia specialists, and programmers who implement the faculty member's course design ideas. These professionals helped me to create a course rich with images and multimedia.[2] A second team, funded by the grant, consisted of an artist and an art historian who programmed animated learning objects created with Macromedia's Flash program based on content and images I provided.[3]

The greatest challenge in the course design was pedagogical: how to teach online. My approach to authoring *ART1300: Art Appreciation* was to translate the face-to-face lecture course into an online equivalent. I seized upon advice I recalled hearing that good online instructors emphasize what they do well in the classroom. All course content in ART1300, therefore, was delivered by the instructor much as in a lecture course. By making this choice, I embraced technology as a tool for delivering content.

My online pedagogy was also shaped by the lack of published scholarship on online course development that seemed relevant to art history, especially on the scale of my large class. There was almost no scholarship on online art history teaching; most articles chiefly addressed teaching with digital images or developing learning management systems (Cason 1998; DeBenedictis 1995; Schmidt et al.1999; Halsey-Dutton 2002) but in or for otherwise traditional teaching environments. At the

[1] For detailed information on UNT's intellectual property agreements, visit http://cdl.unt.edu/index2.cfm?M=16&SM=20.

[2] The images appeared in the lecture text as thumbnails linked to the university's password-protected digital resource center to avoid violating our existing digital image licenses. The finite period in which the students had access to the class also kept the course within fair use guidelines. On the Teach Act and fair use in an educational setting, see

http://www.utsystem.edu/ogc/intellectualproperty/teachact.htm.

[3] CDL staff who deserve special thanks include Jane Himmel, Joey Hoffman, and Michael Wilhelmi. The independent programmers who brilliantly transformed my ideas into interactive learning objects were Lisa Galaviz and Prabha Roger.

same time, there was much research from other disciplines supporting the inclusion of images with text and demonstrating that images aid learning (Paivio 1986; Mayer 1997), but these assumed that the image was secondary to the text. They offered no recommendations concerning how to teach with images. Books and articles on general online pedagogy recommended discussion boards, chat rooms, and other online teaching tools that again privileged the word, not the image; additionally, they were suited to small classes.

To accommodate art history's need to teach with images, I again turned to a face-to-face lecture method. My class was responsible for teaching visual literacy skills. Lecture courses accomplish this through constant modeling of image analysis. The instructor points to the image, identifies its parts, and discusses them (Briggs 1997). He/she projects two images together, allowing the pairing to communicate information visually before making the comparisons verbally. Online courses, on the other hand, are largely text-based, with images usually added merely for visual appeal or "flash" but not for substance. The embedded pictures in *ART1300: Art Appreciation* placed image next to text, as on a book page, but this only integrated text and image asynchronously; students read first, looked second. Therefore, I needed an array of digital tools to recreate this simultaneous modeling of visual literacy through the performative triangle between student, instructor and image discussed by Nelson (2000).

Technology solved some of the asynchrony. In place of in-class demonstrations of different art media, the course offers streaming videos so that text and image would appear simultaneously. Some are demonstrations of art media by graduate students from my university's large studio art department; others are commercial film clips timed to comply with fair use guidelines. After the asynchronous experience of reading the textbook and the html text, students view the clips that join image and word.

To reproduce the action of an instructor pointing to and engaging the work of art, I developed interactive learning objects created with Macromedia's Flash program.[4] In the course's eighteen animated objects, students move their mouse around a digital reproduction of the work of art or perform a sequence of decision-making tasks to create a work of art. In a sculpture exercise, students choose form, material, scale, color, and location to produce their own sculpted image. In one of the "hot zone" interactive objects comparing two approaches to landscape painting,

[4] For a thoughtful analysis of learning objects and their role in instruction, see Churchill 2005.

clicking within the two paintings brings forward information about the works' aesthetic and functional characteristics. These areas lead to additional examples with their own textual explanation. Another exercise moves students through a series of detailed photographs of the parts of a mosque and their purpose (Figure 9-1). A third type of learning object uses a game environment, requiring students to make successful choices to proceed from one room into the next.[5]

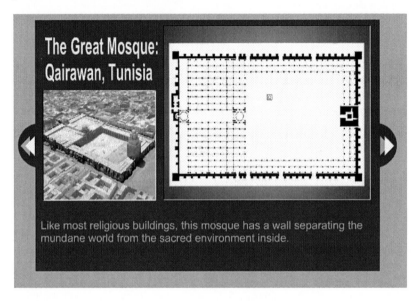

Figure 9-1. Mosque interaction. © Kelly Donahue-Wallace.

By creating the learning objects, I inadvertently created a learner-centered activity in my otherwise instructor-driven course. My goal had been to recreate the professor, but the result was much different. Like Churchill's definition of learning objects, these interactions "enable learners to experiment and construct artifacts and at the same time to learn within...[the] activit[ies]" (2005, p. 338). I was permitting students to make choices, to apply learning, and to move at their own pace and according to their own path within my content. The interactivity reached all three categories of interaction defined in Sims (1997): engagement for navigation, instruction, and control—that is, decision making. Examining these learning objects in retrospect gave me my first insight into another

[5] See Donahue-Wallace and Chanda 2005, on these items and their effectiveness.

approach to learning in online environments. As I set forth authoring the second course, I deployed these types of student-centered learning objects in the learner-driven context discussed in the second half of this essay.

To assess student learning, *ART1300: Art Appreciation* ends each lesson with a quiz and a written assignment. Since recall questions offer little benefit when students have full access to course material during the quiz, the questions require students to apply learned information to new scenarios and objects. Answering the question requires knowledge of content and the ability to apply the information to a new situation. The written assignments likewise require students to analyze and synthesize course material. Students curate virtual exhibitions comparing religious iconography, create two- and three-dimensional objects to illustrate elements of form and principles of composition, analyze the debate over public monuments (the Washington D.C. WWII Memorial, for example), or write the biography of a fictional artist. Students are provided with the grading rubrics for the assignments, which are tied to course learning outcomes.

Overall, traditional art history pedagogy drove the use of technology in *ART1300: Art Appreciation*. The e-learning course is a linear narrative that is largely faculty-directed. Its digital elements have as their goal the reproduction of the lecture experience, with the exception of the written and creative assignments. More than 500 students eagerly sign up for the course each semester; more importantly, instructors and teaching assistants volunteer to work with the class repeatedly. My observation reveals that grades are no higher or lower than in the 300-student face-to-face section, and the university finds that the class is achieving its learning outcomes. A study I co-authored earlier (Donahue-Wallace and Chanda 2005) revealed that the lesson format combining html text and interactive learning objects helps students to learn course content thoroughly and with a great command of terms and concepts.

A Community of Learners

The circumstances surrounding the second online course, *ART2350: Art History Survey I*, were similar. Once again the impetus to authorship was a university grant and I could count on the talents of the Center for Distributed Learning and at least one of the artist/programmers I employed before. This class, however, is only a fraction of the size of the other class, with one instructor serving only 45 students each semester in the online section. The course is a global review of art and architecture from

prehistory through 1400. As in *ART1300: Art Appreciation*, content in *ART2350: Art History Survey I* is organized into eight, two-week lessons.

Other aspects of the authoring experience also differed. As I approached writing the second time, I had more experience both composing online materials and teaching online classes. I was also more familiar with the literature of online teaching and the recommendations for structuring classes. As a more experienced professor in general, I understood better the course's learning outcomes and how they fit the department's larger goals. Our program seeks transferable skills rather than specific content knowledge, so I wrote the course to promote skill-based outcomes. Additionally, the course development grant was smaller, just under $10,000, with only enough funds to buy my summer course reduction and to pay the hourly wage for one learning object programmer.

My experience writing and administering *ART1300: Art Appreciation* led me to seek a different approach to teaching for the new *ART2350: Art History Survey I* class. I wanted the instructor to play the role of the facilitator, not the sage. Fortunately, an available art history survey textbook closely mirrored my approach to the material, meaning that I was comfortable letting the textbook, Honour and Fleming's *The Visual Arts: A History*, be the content expert. Freed from the need to author content, I was able to focus on developing a technology-based pedagogy and assessment strategy that promoted the discipline's essential skills.

To help the students work through the textbook and to develop the skills of art history, I adopted a modified Problem-Based Learning (PBL) model for the class.[6] This active-learning, constructivist approach requires students to work together to arrive at the resolution of real-world problems. Student learning through PBL is comparable to learning in face-to-face classes (Duch et al. 2001; Schwartz, 2001). More importantly, the knowledge is transferable. Students develop the skills required to solve challenges and learn how to seek and deploy knowledge rather than merely to memorize facts (Lindner 2005). PBL communication additionally builds a community of learners that mitigates the isolation of online courses. Members of this community are also more likely to ask routine questions of their peers, saving the instructor from repeated answering the same low-level inquiries, a common complaint among online instructors.

The PBL scenarios in *ART2350: Art History Survey I* follow a single narrative throughout the semester as each student in the course plays a

[6] I altered the standard Problem-Based Learning method by making all assessment individual rather than collective.

role. The student begins as a hapless art history major looking for a summer internship. In the first lesson, the student meets his/her employer, the fictitious Professor Huffpenagle, a famous art historian who is terribly overburdened in his investigations. In this and other lessons, Dr. Huffpenagle happily dumps his work in his research assistant's lap.

The PBL tasks are somewhat exaggerated versions of the real-life work of art historians. For the lesson on prehistory, for example, the research assistant must travel to Europe and the Middle East to sort and classify the Paleolithic and Neolithic objects found at the two sites. This initial Problem requires the student to develop her/his visual literacy and compare the newly-discovered works to objects discussed in the textbook. The Problem reveals to students that visual comparison of unknown to known is central to certain practices of art history. It also reinforces knowledge of pictorial conventions, chronology, iconography, and function learned from the reading. In this first lesson, students work alone, chiefly because the long add/drop period at the university makes fixed groups challenging at this early point in the semester. The individual work also (hopefully) reveals to students how much easier the task and better their answers would be if they could discussion questions and ideas with their peers.

Subsequent Problems are more challenging and group interaction becomes increasingly frequent and productive. The first lesson on antiquity—covering Old Kingdom Egypt, Shang Dynasty China, the Indus Valley, Mesopotamia, and the ancient Aegean—requires students to extrapolate what Dr. Huffpenagle found when he discovered a new ancient empire. Students use their own creativity to invent the palaces, temples, public monuments, and other objects of the new civilization so long as the objects and monuments they describe reflect the logic of form, iconography, and function of real coeval empires. Students use the discussion board to talk about their ideas for the new civilization, summarizing its religion, politics, and culture. Posting at least once to the discussion is mandatory, but many students continue to interact beyond the required posting.

Figure 9-2. Murder mystery crime scene. © Kelly Donahue-Wallace.

In the last lesson, students parse ekphrastic texts. Here the research assistant is asked by Professor Huffpenagle to solve a seven-hundred-year-old murder mystery. Working from an interactive crime scene diagram (Figure 9-2) and transcripts of witness and suspect testimony, the research assistant must decide who killed a pilgrim on the road to Santiago de Compostela. Witness testimony involves art and architecture, with descriptions of the materials, forms, and iconography of Romanesque and Gothic objects and monuments; the described works are linked to digital images. The research assistant is warned at the outset that the killer is the person who gets his or her art history wrong. The murder mystery game not only reinforces content, but develops students' skills in reading images and weighing written information against the images as the primary source. The group discussions for this lesson are lively, as students debate the suspects' testimony and challenge each other on their conclusions.

The course and its pedagogy were developed hand-in-hand with the technology. Each lesson operates on a two-week schedule. The students have the first week to review the introduction to the Problem and read the textbook chapter(s). Before the week is over, students have three chances to take a reading quiz; the remainder of the Problem, instructions for its completion, and additional resources are not released until the student achieves a score of 70% or better. This assessment ensures that the students have the content mastery needed to complete the Problem

successfully. Students who fail to achieve the 70% benchmark forfeit the remainder of the lesson and its points.

Since textbook chapters tend to be long and some students fail to appreciate the key concepts, each lesson includes interactive learning objects to reinforce important information. Students review these interactive animations before attempting the gate-keeping quiz. The learning objects are divided into sections addressing pictorial arts, architecture, and art in context; each section includes a list of terms and concepts relevant to the material. Clicking the term brings up the definition and takes the viewer to an area of the interaction related to the term or concept (Figure 9-3). As in *ART1300: Art Appreciation*, the learning objects use the synchronous presentation of text and image to model visual literacy and emphasize selected ideas. In this course, however, these interactive animations function as student-directed tutorials, presenting content in a non-linear manner. That is, the learning object does not replace or recreate the narrative of the textbook chapter, but instead selects terms and ideas and makes comparisons from throughout the textbook chapter's content.

Figure 9-3. Tutorial learning object. © Kelly Donahue-Wallace.

The second half of each unit (Phase Two), in which students work to solve the Problem, likewise integrates the technology into the pedagogy. Upon successfully demonstrating content mastery with a quiz score of 70% or better, the student is provided with the remainder of the lesson. This section of the unit gives the full explanation of the Problem and provides additional resources. These resources include museum websites or streaming video to present content in different ways. This section also includes the discussion board. In early lessons, discussion postings are mandatory; later they are encouraged, but not required. When participation in group discussions is voluntary, participants receive extra credit for presenting ideas to their peers. The group with the most thorough and thoughtful discussions earns additional extra points. This approach to discussion boards creates a community of learners for the students who crave this type of experience and allows those who abhor group work to avoid it. It rewards those who want to make full use of the discussion board to work out their ideas, while also permitting "lurkers" to benefit from "listening" to the discussion, just as they would in a face-to-face class; the lurkers do not earn points, but benefit from reading the discussions.

As an art historian and an instructor, I prefer *ART2350: Art History Survey I* to *ART1300: Art Appreciation*. Students seem more engaged than in the other class. They are more creative and their enthusiasm shows in their discussion postings and Problem solutions. Their answers reveal to me all of the thought processes I want students to employ and all of the questions I want them to raise. More importantly, the students exceed the ideas and questions I anticipated as I wrote the survey course and developed the assessments. Another aspect of the course I find highly appealing is the integration of pedagogy and technology; the two work together. Whereas *ART1300: Art Appreciation* is a good class that just happens to be online, *ART2350: Art History Survey I* is a good online class.

CHAPTER TEN

MOTIVATING PARTICIPATION IN ONLINE ART
HISTORY COURSES: ISSUES AND IDEAS

GEOFFREY SIMMINS

Like many art history instructors, I have expended considerable energies
developing online and blended-learning online art history courses. But my
students have not participated online as enthusiastically or in as much
depth as I had hoped they would. In the movie *Field of Dreams,* Kevin
Costner builds a baseball diamond in the middle of a cornfield and
manages to attract a big-league lineup of players, including his own
deceased father. "If you build it, he will come," a catchphrase in the
movie, suggests that simply doing something will surely be rewarded with
success. In my own case, I felt as though I built the diamond and no one
emerged from the tall corn.

Having now reflected on this experience, and considered different
writings on this subject, I would like to offer some remarks on the subject
of motivating art history students to participate more willingly in online
courses. Online courses are rapidly proliferating. But we still need develop
ways of teaching that our students will find rewarding, challenging, and
will motivate them. Students will not automatically want, or feel
motivated, to participate in online classes and discussions. Our students
lead multiple lives, and are consumers as well as students. We owe it to
them and to our discipline to do as much as possible to make their online
experience meaningful and challenging. The benefits are clear, and the
issues important.

Motivation Techniques

Much of the substantial body of literature on motivating online students
presents common sense solutions, emphasizing principles in teaching to

which anyone should adhere.[1] To take one readily accessible example, Lana Becker and Kent N. Schneider, from East Tennessee State University (2004), have isolated the following eight strategies: repeating critical concepts; providing students with a visual aid to explain abstract concepts; developing logical skills of analysis; using in-class activities to reinforce newly presented material; helping students link the old with the new; reinforcing and developing competence in the specific vocabulary of the discipline; treating students with respect; and holding students to a high standard. These are all excellent principles by which to teach.[2] We also need to be mindful of approaches that might be called demotivating. What demotivates students? Among other things, are technological glitches, too much information (lists of lists or too many works of art), a lack of response from their instructors, and feeling concerned about their peers' reactions if they are *too* keen in participating (the "nerd" factor).

Assessing Pedagogical Strategies

Teachers in online art history courses need to look not just at the issue of motivation, but also at their assumptions regarding the predominant learning styles of the students are in their classes. I had *assumed one kind of learner as my norm, but learned that such learners are actually not the majority of the class*. The ideal learner in an online setting is a non-traditional learner, often highly and intrinsically self-motivated (Gibbons and Wentworth 2001). But of course, most of us are teaching online courses now that *substitute* for established courses, to which we attract traditional learners, not non-traditional learners. To put it another way, art historians who have developed online courses seem to have been working with an established pedagogy and trying to adapt it to a form where a different approach might be called for. The term "andragogy" has been coined with reference to the typical online learner. "*Pedagogy* describes the traditional instructional approach based on teacher-directed learning theory. *Andragogy* describes the approach based on self-directed learning

[1] The University of Honolulu offers online resources on motivating students. See http://honolulu.hawaii.edu/intranet/committees/FacDevCom/guidebk/teachtip/teac htip.htm#motivating

[2] Authors associated with Brenau University, in Gainesville, Georgia, have written very useful articles on motivating online learners. Brenau has offered online degrees since 1998 in a variety of disciplines, including an online M.Ed. degree program in Early Childhood Education and in fall of the same year a MBA in Accounting from the Department of Business Administration. A third M.B.A. program was introduced in Healthcare Administration, in spring of 2002.

theory" (Gibbons and Wentworth 2001). A general view is that "online education is primarily directed to nontraditional learners. Historically, nontraditional learners have been defined as persons over age 25" (Whisnant, Sullivan, and Slayton 1992; Gibbons and Wentworth 2001). Moreover, "Typical distance learners are those who don't have access to programs, employees who work during scheduled class hours, homebound individuals, self- motivated individuals who want to take courses for self-knowledge or advancement, or those who are unable or unwilling to attend class" (Charp 2000, 10). As Gibbons and Wentworth observe in their article on andragogical learning (2001), "Learning a subject well *requires* [the ability to provide] intensive discourse in that field, whether it be math (Mokros, Russel, and Economopoulos 1995), science (Gallas 1995), social studies (Lindquist 1995), literature (Brady and Jacobs 1994), or any other discipline" (Coulter, Konold, and Feldman 2000). "The learners' ... need for individual dialogue" contributes as much to the teaching and learning structure as the teacher offers in the way of course content or design (Saba 2000, 4). Taking these remarks into account, I had probably misunderstood the goals and learning styles of my students.

Creating Online Communities—and Norms within Them

Once we consider the learning styles of our students, and look again at what sort of strategies we can adopt as a means of motivating students, we are better able to assess how and what sort of community we wish to build. As teachers, we need to be personal and personable, clear, and delimit information appropriately. We need to model standards, review our teaching strategies, and develop clear norms. If our goal is to create "student-centered communities of learners" (Knowlton 2000), we can either adopt an interventionist or a non-interventionist approach. Perhaps more intervention than less seems to be the path to follow. Research suggests that we need to establish norms, and expectations, to reinforce the behavior we want, and discourage the behavior we do not want. I have never had any problems with rudeness or inappropriate posts. What I *have* had a problem with is a lack of depth. I think we need to foster a climate in which critical inquiry becomes a norm. I recently had a post by a student who apologized for knowing something, and said, "I guess that shows that I am a nerd." We need to foster a climate in which being a nerd is not only OK, but normative if that's possible.

The Continuing Revolution: New Technologies
and their Impact on Our Teaching

More has changed in art history in the last ten years than in the previous century. Yet still no universally accepted practices have come to replace the old two-slide-projectors-in-a-dark-room norm. While waiting for new universal standards to emerge—if in fact this will occur—what can we do? For starters, we need to remember the obvious: do not give out hard copies of assignments or outlines, but instead give only online versions. These predispose students to look first online, rather than seeking out the instructor in person. We also need to work to employ the tools already at our disposal well. Blackboard and WebCT (and other course management systems) enable instructors as well as students to introduce documents, images, external links, and multimedia files in a consistent format. We are able to introduce discussion topics and groups to which students can be assigned according to different criteria. Such tools allow the introverts in a given class to reflect carefully before they participate, then add their contribution when they are ready. In contrast to a face-to-face class, no single person or small group can dominate the discussions. Figure 10-1 shows an example of sample discussion boards from one of my classes, on nineteenth-century art.

In the discussion forum, I can quickly respond to articles in the press on art history, or link to specific events. I find it easier than ever before to refer to literary or philosophical developments that are relevant to art history. I am able to respond more quickly to topical issues than I could before; this helps motivate students when they see that the online material is topical and relevant to discussions.

2 ⟐ **French Realism and Naturalism** (Modify) (Remove)

This forum is devoted to discussions on French Realism. Number of
Wonder why Courbet was so dogged about not painting what he couldn't see? Because he was influenced by POSITIVISM, Messages: 15
a movement in philosophy started at this time. If you have a bit of time, I recommend this link: All read
http://www.historyguide.org/intellect/lecture25a.html
See under Auguste Comple. This will help explain Courbet quite a bit. For a link to realist literature (it's called Naturalism),
see: http://www.wsu.edu:8080/~brians/hum_303/naturalism.html

Interested in Napoleon III? Here's a great illustrated site!
http://www.napoleon.org/en/essential_napoleon/key_painting/second_empire.asp

3 ⟐ **Pre-Raphaelite Brotherhood** (Modify) (Remove)

This forum is devoted to discussions of the Pre-Raphaelite Brotherhood. A good starting point is the Victoria Web, at: Number of
http://www.victorianweb.org/; even if the links aren't all working, the site is still very rich indeed. And of course the text has Messages: 19
quite a bit on the PRB. A couple of other pages: http://persephone.cps.unizar.es/General/Gente/SPD/Pre-Raphaelites/Pre- All read
Raphaelites.html http://www.dlc.fi/~human/preraph.htm http://www.cwrl.utexas.edu/~bump/E320M/PRB.html Obviously,
you won't have any trouble finding images of the PRB; the challenge is to make sense of them!

4 ⟐ **Themes and Ideas** (Modify) (Remove)

This forum is devoted to the broader currents of social and intellectual life. Number of
 Messages: 15
 All read

5 ⟐ **Visiting Lecturers on Graduate Study in Britain** (Modify) (Remove)

This forum is devoted to organizing a visiting lecture in connection with graduate study in Britain. Number of
 Messages: 1
 All read

6 ⟐ **Open Forum** (Modify) (Remove)

For whatever tickles your fancy, within the bounds of decorum, of course... No Messages

Figure 10-1. Example of Discussion Board, taken from author's 2006 Blackboard suite for a course on nineteenth-century art. © Geoffrey Simmins.

In fact, the new technology is promising to overturn one of the hallmarks of online teaching—that it is taught asynchronously. Software such as "Elluminate Live!" permits real-time teaching (Figure 10-2).[3]

[3] ElluminateLive is web-casting software that enables instructors to have real-time discussions with students. Synchronous discussions can be complemented by PowerPoint slides, websites, whiteboard mark-up capability and shared applications. ElluminateLive can also be used for blended learning, which might include guest presenters, support for student group project meetings, online tutorial/lab sessions, peer-based tutoring, exam review, virtual office hours, and mentoring.

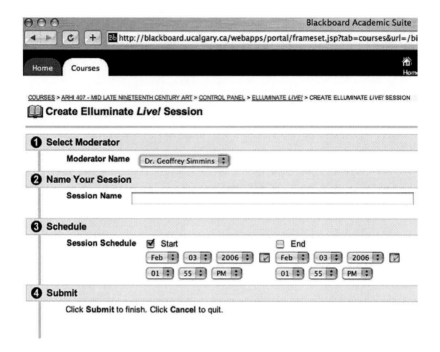

Figure 10-2. Elluminate Screen taken from author's 2006 Blackboard suite for a course on nineteenth-century art. © Geoffrey Simmins.

I have also used the Survey tool to good effect. This allows instructors to ask their students questions about any given issue. Provided that we use it in a timely fashion, and take the students' comments seriously, this is an excellent tool. In my case, I used the Survey tool to ask students about what kind of assignments they wanted for the course. I offered them either tests or a research essay. I looked at the results—which were overwhelmingly tilted towards the former—and gave them their choice. One student somewhat sardonically observed that people often choose that which they know, and she, for one, would have preferred being assigned a research paper. I saw her point, and offered students an optional paper.

But we need to be very careful to be in control of the material, rather than the other way around. Michael Greenhalgh (2002) cautions the art history instructor who simply uses "undigested" material from the web, and argues strongly that we must do more than simply assemble images. He writes:

This point needs emphasizing: having accessible websites with the necessary images is but the first step in lecturing using the web. For to teach using web multimedia, "regimentation tools" are needed. The visual materials must be to hand—all the ducks must be in a row before the lecture starts, since the students can surf the web for themselves, and need their lecturer to have everything assembled (after all similar skills to those we demand of a student essay or presentation). This is especially the case in disciplines such as art history, where the images, usually shown two by two for comparative purposes, are the primary documents. Although there are myriad software packages to aid the manipulation and display of individual images on computers, none are set up explicitly to aid presentation of large quantities for comparative purposes via a web browser, and so I have commissioned a series of software tools to help with the important tasks required to prepare image databases using the web, and then the selection of images from these databases for use in the lecture theatre.

We embrace—indeed, demand—openness to other disciplines, such as literature, history, and communications studies. Our inherent focus on visual media is uniquely suited to the growing potentials of multimedia. Outside sources that are valuable to us include museum websites as well as the department sites of cognate disciplines, such as English or communications studies departments, which often provide excellent for information on visual arts theory, as well as the connection between the visual arts and literature, e.g., Dante, or Blake. National museum websites, which often have excellent background materials as well as first-rate images, are preferred to instructors' lists of lists (including my own). Still, we need to be mindful to reduce the number of links we use, and to try to improve their quality. First-generation online teaching featured endless lists of lists. Those days are over.

Perhaps the best things we can do are *take the best standards and principles from slide-based lecture teaching and try to adapt these to the new methods offered by online teaching.* Chief among these is what R. Nelson (2000) has termed "the performative triangle consisting of speaker, audience, and image." Kelly Donahue-Wallace has co-authored an article (2005) in which she addresses particularly this point of the performative triangle, and offered a case study in an online art history course. As the authors observe: "Primary among art history's demands is visual literacy, the ability to approach visual materials not as scientific documents or objective records of past events, but as a form of communication and creative endeavor." In the article the authors go on to describe two ways that they have attempted to introduce Nelson's "performative triangle" into online courses—the first by introducing the animated figure of a young

woman who acts as the student; and the second by introducing "motion graphics" (see Figure 10-3).

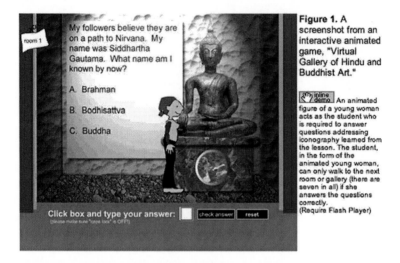

Figure 1. A screenshot from an interactive animated game, "Virtual Gallery of Hindu and Buddhist Art."

An animated figure of a young woman acts as the student who is required to answer questions addressing iconography learned from the lesson. The student, in the form of the animated young woman, can only walk to the next room or gallery (there are seven in all) if she answers the questions correctly. (Require Flash Player)

Figure 10-3. Kelly Donahue-Wallace and Prabha Roger, Hindu and Buddhist Gallery Interaction. © Kelly Donahue-Wallace.

As these authors have suggested, we need still to identify which principles and practices of teaching *are specific to art history and not another discipline*—the interaction between object, teacher, and student, for example. In this case, the new technology is applied to an old teaching principle.

A larger point to be discerned from this example is the way that the technology permits interactive exploration of a given concept, thus rendering the role of both the professor and the student more fluid. The professor is not, as in a traditional classroom, regimented, disseminating information that is obediently copied (not that this triangulated model suggests quite this degree of passivity). Rather, "In online student-centered education, the professor serves as the facilitator, while students collaborate with each other in order to develop personal understanding of course content" (Yang 2005). Yang expands on this point, writing: "in traditional professor-centered education, the roles of professor and student are regimented; the professor disseminates knowledge, and the student reflects that information. However, as Knowlton (2000) has argued, in the student-centered online education course, the professor and students are a community of learners. The professor serves as coach, counselor and

mentor; the students become active participants in learning. During the processes of learning, in teacher-centered classroom, professor lectures while students take notes. In online student-centered education, the professor serves as the facilitator, while students collaborate with each other in order to develop personal understanding of course content" (Yang 2005).

The Trap of Blended Learning:
Asking Too Much of Students

Blended learning isn't simply a matter of adding more onto the students than they already have to deal with. I admit that I have failed to reduce the amount of classroom time –replaced by effective Web-based teaching. The challenge is not to create a *Doppelganger* of our own live course, but a complement to it. I find it useful to remember that our students are busy people, with working lives outside university, as well as being sophisticated and canny consumers. They ask: why do I have to do this? Is this extra to the course? We have to think through what assignments we ask them to undertake, and show them how the online information will help them achieve their goals. It might well be that this will require, in the case of blended-learning courses in particular, canceling some scheduled lectures in recognition of the extra work required in the online component of the class.

We're-Going-to-Dialogue-Whether-You-Like-It-Or-Not!

This leads me towards the issue of how to ensure student participation online. I have experimented with several methods. I have tried both optional and required participation, and I found that only by increasing the participation grade to between ten and twenty percent was I able to achieve the level of participation I had been looking for. Second, I have required a certain minimum number of posts in a given time (usually per week).

This approach is not without its problems, especially in larger courses. And when we do require a certain minimum number of posts, we need to be sure what exactly we mean by "participation." A conversation with a colleague from the Weekend University of the University of Calgary has offered at least one method that might be helpful. A TA in a communications course suggested that the students be told that a post stating something along the lines of "that was interesting" should automatically be graded at a zero. Instead, students are required to respond

to specific questions with textual support. In the case of art history, "textual support" might mean several things: responding to specific questions about a given work of art; responding to text and/or lecture notes about a given work of art; or else responding to, say, an excerpt from a work of literature (Dante's *Inferno*, for example), and connecting that with a given work of art.

Obviously, it would be good if all students were self-motivated and needed just carrots, and no sticks. But if our goal is to create community, then perhaps the single best strategy we can adopt is to make clear what "being part of a community" means. And if that means insisting that a certain number of posts are required, then this seems a reasonable expectation. I recognize, however, that others have wrestled with this issue and have reached different conclusions—that requiring participation is tokenistic and counterproductive.

Towards Effective Online Art History Teaching: A Tentative Checklist for Action and Renewal

As the old Chinese proverb has it, we live in "interesting times." We are, like it or not, part of a generation of pioneers. And like the pioneers of old, many of the plants we sow (in a teaching sense) are doomed to wither and fail, or fall on stony ground, and some of the fields we till will have to be abandoned. But that should not stop us from being enthusiastic about the times in which we live. So long as we take seriously the idea the we are creating communities online, and think about the learning styles of our students, then what we offer them will result in new ways of teaching art history, bringing together the triangle of speaker, audience and image. Remember: looking at slides in a dark room was a century-old model. We're embarked on making a new paradigm for teaching art history. Towards that end, I have developed a preliminary checklist that we might want to consider as we move into the second generation of design and redesign of online courses.

- What are we doing to motivate dialogue in our online teaching—and what are we doing to analyze whether this dialogue is effective?

- Can we speak of our courses as communities of learning? If so, how has this been achieved? If not, why not?

- Are we learning new technologies and trying to apply them to our teaching—e.g., Elluminate, and others? Do we look on this as an integral part of our professional development?

- If we require a minimum level of participation in our classes, have we developed criteria for assessing the *quality* and not just the *quantity* of posts?

- Are we attempting to integrate multimedia, and not just static images?

- In our classrooms, we may have abandoned the idea of being the sage on the stage in preference of being the guide on the side. What persona do our online courses present?

- Are we (if in positions of influence) asking our administrators for appropriate credit, and/or time to modify our courses for online delivery...and keep on modifying them?

- Are we (if in positions of influence) making sure that junior faculty members are not the only ones doing online teaching?

We are pioneers working towards new norms in art history teaching. In order to do this, we need to be open to experiment, open to student feedback and critique, and open also to sharing our ideas widely so that we can work together, in order to motivate students and ourselves.

CHAPTER ELEVEN

TWO REFLECTIONS ON ART HISTORY
E-LEARNING

EVA J. ALLEN
AND KELLY DONAHUE-WALLACE

Attempting to predict the future of art history delivered via distance learning technologies is a fool's errand. By the time we write these words and see them in print, the technologies and practices we identify will have already been implemented; others will have been rejected in favor of new approaches we have not yet imagined. It is nevertheless worth reflecting on the moment's cutting edge practices and their pedagogical potential in the online art history class. At the same time, we seize this opportunity to reflect on online art history as a discrete category within the discipline, to assess its standing, and to offer advice for its future. Although this pairing may seem awkward, both sections nevertheless arrive at similar conclusions about the future of online art history.

Some Trends of E-learning in Higher Education (Allen)

The essays on online art history in this volume generally reflect the nature of what has come to be known as Web 1.0: they are primarily information delivery devices. But it is the external Web environment that is changing most rapidly. New technologies and practices are emerging under the banner of "Web 2.0" and the rubric "*social software*." Alexander (2006, 33) explains there is not one single definition of Web 2.0; it rather represents "a mix of relatively familiar and also very emergent technologies." It includes a number of "concepts, projects, and practices" as "blogs, wikis, trackback, podcasting, videoblogs…RSS feeds," to mention only a few that have emerged from Web 1.0 applications. The "*social software*" label designates their ability of giving users the opportunity to create, share, interchange information, and foster

collaborative work. Alexander further comments that they have became crucial in higher education in the past two years. The static "book format" with the "page metaphor" of Web 1.0 applications gave way to the user-friendly, dynamic applications of Web 2.0. "Blogs are about posts, not pages, Wikis are about streams of conversation, revision, amendment, and truncation. Podcasts are shuttled between Web sites, RSS feeds, and diverse players."

As Harris and Zucker noted elsewhere in this volume, the terms wiki, blog, RSS feeds, and open content, among others, are increasingly entering the vocabulary of those of us who teach online, not to mention the personal world of our students. Whether we as faculty like it or not, our students are already using these tools. What are the implications for the future? At the University of Maryland University College, some of these new applications are simply the next phase of an ongoing evolution. UMUC has been at the forefront of distance education for many years.[1] The faculty is fortunate that the developers of the WebTycho CMS not only established a stable platform, but were visionary in anticipating some of the Web 2.0 features now gaining popularity. The underlying concept of the Conferences system discussed in my essay earlier in this volume, for example, is similar to that of the popular Web blog. It encourages students to post their own entries, respond to peers, read and comment on one another's responses, post questions to one another, and develop a dialogue and a sense of community with peers. Conferences also allow incorporation of links, images, and multimedia features.[2] Course

[1] See Allen's individual essay in this volume. Distance education here refers to several concepts and practices; however, its basic meaning is that students and faculty are separated either in time or space or both during the learning experience. One of the oldest delivery systems was correspondence courses. More recent forms, however, are instructional TV, video conferencing, audio conferencing, and online delivery. UMUC uses primarily online delivery.

[2] I have used these features in my ARTH 370 course for some time, including MP3 files and PowerPoint presentations with audio enhancement that some students feel make the class more real. UMUC purchased the Adobe Connect Enterprise (formerly Breeze) software from Macromedia Flash and has made it available to faculty since fall 2006. In principle, this is a highly interactive tool that includes several applications in one as: synchronous and asynchronous meetings, live presentations, screen sharing, video clips for later playback, and creation of various multimedia applications. Breeze, however, is still a complex application and we look forward to a more seamless, direct application in our future TychoNG platform. I thank Traicy Garey, Assistant Director of Course Design and Development for demonstrating the use of Breeze software to me.

management systems at other institutions include similar tools, such as Blackboard's Class Blogs, for example.

Web 2.0's other features are similarly found in current versions of course management systems. The hugely popular *wiki* application is packaged in WebTycho, Angel, Blackboard, and other course managements systems. Students work in teams to create and exchange information and images, and to share, edit, transform, and delete material while preparing a collaborative document. Another WebTycho function, Webliography, has characteristics of the popular Web 2.0 tool, bookmarking; Blackboard's Web Links operates similarly. Here, students and professor assemble a bibliographic list from important Web sites that can be tagged and annotated for communal use and easily retrieved at any time. Finally, several course management systems mimic Web 2.0's social networking sites Facebook and MySpace with sites where students post personal biographies, attach personal photos, and list their individual Web sites. The task for UMUC and other system developers now is to keep updating these early Web 2.0 applications so that students can use them as smoothly within our formal classroom environment as they can outside the University in informal learning situations. Other educational institutions face this challenge as well as they integrate social software into Blackboard, Angel, and other course management systems.

Faculty also increasingly turn to other sites outside the college or university to increase student engagement and participation in the course. Museum websites permit users to build their own exhibitions and galleries of images. Course and art history interest groups abound on Flickr, allowing art history students and instructors to interact with each other and with the non-academic world. Virtual constructions on *Second Life*, such as the recreation of the Sistine Chapel by Vassar College, begin to explore the pedagogical potential of an immersive environment as well as a social and interactive one. In short, art historians are exploring each technology the Internet puts at our disposal.

The emergence of open content, or open educational resources (OER), websites adds another new dimension of opportunity and complexity. OER sites enable us to learn how other faculty and institutions are using technology and pedagogy; they provide an opportunity to freely use or modify the content of others, to put up our own in return, and to collaborate with other faculty to make improvements and innovations, usually with minimal restrictions through public domain or creative commons license. The content and services of these sites are equally available to students as well. The movement is gaining momentum. Some notable websites worth watching are, among others:

- OER Commons (http://www.oercommons.org/),
- MIT OpenCourseWare (http://ocw.mit.edu/index.html), and
- ConneXions (http://cnx.org/)
- OpenLearn (http://openlearn.open.ac.uk)

The proceedings from a recent world conference on Web 2.0 convened under the umbrella of EDEN (European Distance E-learning Network) in Naples, Italy gives insight to what is happening in the global higher education arena in light of Web 2.0 applications. Amid the proliferation of papers on the use of various social software applications in online courses, one presenter felt academic institutions are not moving productively or fast enough in face of the demands of our "knowledge based society" (Geser 2007). While social software, he believes, is ideally suited to learner-based, collaborative approaches, he worries there is not a strong commitment from the part of administrators to implement educational innovations and make organizational changes. This presenter expressed that students are already active beyond the education walls and already operate the "low-barrier and easy to use tools and services" the Web offers. Why not bring the realities of students' lives outside of the classroom into balance with their learning experiences within their institutions? Information Technology systems often operate, Geser (2007) notes, from a "top-down approach with centralized information access, authoritative information, defined user roles and permits."

What does Web 2.0 offer art history e-learning courses? These tools present our students with the opportunity to collaborate, to build knowledge in communities of practice, to introduce their own experiences and intelligences into the content provided, or at least framed, by the instructor. One thing is certain, the emergence of innovative Web 2.0 technologies will challenge those of us who teach online to keep up, as they will challenge our institutions.

Just how far should we go? The Internet and its technologies adapted for classroom use offers online art history a wealth of resources. Social networking sites bring interested parties together from across the globe to discuss course content. YouTube provides videos of sites and monuments and allows students to make and share their own contributions. Downloadable audio files for museum or walking tours can likewise be instructor or student driven. Wikis build knowledge communally. And so on. These tools can be employed directly from the Internet or recreated by the course management system's programmers. They can serve the self-contained course, in which the instructor has provided the course content, or the more open course, in which the instructor raises questions and shepherds students through a largely un-predetermined learning

experience. In all approaches to art history e-learning, instructors looking to give their students access to the array art historical resources available through the Internet have a vast menu of choices.

As the essays in this volume demonstrate, however, the use of technological bells and whistles in online art history, as in face-to-face courses, must have a pedagogically sound purpose. Art history as a discipline and as a practice has unique needs; art history programs have specific objectives as they seek to prepare new practitioners for graduate study and entering the profession, or simply to equip learners for a more informed and fulfilled life. Like online art history courses themselves, whether any of the resources outlined above will be of value to us as educators depends upon finding material that is useful to accomplishing the learning objective of a particular module, course, and program, and ensuring that the material is well researched, designed, and accessible to meet our students' needs. Just as instructors increasingly design activities to help students become savvy users of Web resources, we too need to approach Internet materials with care.

What do we want from online art history?
Why are we afraid of it? (Donahue-Wallace)

Whatever shape art history e-learning takes with the introduction of these and other tools, it faces an uphill battle. Why? To be blunt: many art historians do not trust online education and this mistrust shows no sign of abating in the near future.

The reasons given for undervaluing art history online classes are many. My own experience has revealed to me that there is a widespread perception of online art history courses as expeditious solutions promoted by university administrators and state legislators, rather than serious and thoughtful contributions to the field. Instructors and administrators seeking rapid transformation of material into the online format do so for economic reasons and have not always taken care to make sure that the classes they create are good classes. Courses are created by adjunct instructors at some community colleges and universities rather than by the faculty invested in the success of the program. Other courses can be purchased and plugged in at any school, requiring little more than a manager to watch over the students in the class. As in other disciplines, art history faculty fear that college administrators will view online courses as a solution to the "problem" of a permanent and benefits-eligible faculty; the proliferation of online courses will result in the death of tenure and its academic freedoms. Finally, the argument goes, art history simply cannot be done well online;

it may be suited for other disciplines, but not for ours and especially not at the graduate level.

In many ways, these fears are well-founded. There are plenty of poor online art history classes offered by colleges and universities. Unqualified adjuncts are set in front of computers to monitor classes that they did not author. The classes proliferate in response to economic pressures rather than pedagogical or curricular needs. Some tenure-track faculty positions at colleges and universities may very well disappear, replaced by adjuncts teaching "canned" classes purchased from free-lance authors, other colleges, or commercial sources.[3]

But the same could be said of many art history classes taught face-to-face. We can all think of bad teachers and substandard classes we have witnessed in our educations and careers. We have seen faculty-to-student ratios swell at large public universities, with more and more teaching done by graduate students and adjuncts ineligible for benefits. No one, however, is arguing that face-to-face classes are inappropriate for our discipline. No one condemns the entire practice of face-to-face art history classes because of a few (or many) bad classes.

Why hold online courses to a higher standard? Why do face-to-face classes taught by poor instructors using outdated content and ineffective teaching methods not receive the same level of scrutiny? What are we afraid of about art history e-learning?

In part, the answer lies in online teaching's youth. Experience tells us that art history students who take a poorly taught face-to-face class now and then will nevertheless likely complete the program in fair shape, having learned most content and requisite skills fairly well to succeed in graduate study or entry-level jobs. We know this because we have confidence that the well-taught face-to-face classes compensate for weaker courses and provide all of this knowledge and all of these skills. A bad apple won't spoil the barrel. We do not have the same confidence in art history e-learning; some faculty doubt online education's ability to teach at all.

A second answer lies in biases against the online instructor and the online student. Many online instructors in our discipline are either adjunct or teaching faculty, and hence are traditionally the least esteemed members of the academy. To compound the stigma, online instructors are unseen as they work from remote locations and their intelligence, teaching skills, and professional accomplishments go unnoticed. When tenure-track faculty participate in online teaching and course development, they are

[3] See for example Carlson 2003 and Cavanaugh and Cavanaugh 2006.

generally junior faculty whose facility with new technology and whose lack of experience worry their senior colleagues. These young assistant professors may embrace e-learning, but they lack the academic weight to convince more senior colleagues of its validity. Faculty are similarly wary of students who take online classes. Is a student who prefers to take an online class trying to get away with something or to avoid a demanding faculty member or a rigorous program?

In neither case is art history unique in this mistrust of online education, its faculty, and its students. A recent study of employers in all areas revealed that the majority of organizations still preferred to hire applicants with degrees from face-to-face programs, although this attitude appears to be changing (Carnevale 2007). The hiring officers of these companies were wary of any courses taken or degrees granted via distributed learning, regardless of the host institution. Similarly, junior faculty who develop online courses in all disciplines are often imperiled as they seek promotion and tenure (Young 2002).

But a third piece of this puzzle rests with the discipline itself. Art historians are reticent to talk about teaching practices. Our organizations only marginally embrace good and effective teaching, not just knowledgeable lecturing, as a goal within the profession. Although the early publications of the College Art Association were dominated by articles on pedagogy and classroom strategies, these questions virtually disappeared from the *Art Bulletin* and the *Art Journal* after 1960 (Ball 2005). Pedagogy sessions likewise were largely absent from the association's annual meetings. With notable exceptions—the 1995 *Art Journal* issue dedicated to the survey course and the 1997 *Art Bulletin* issue addressing digital images—it was not until the early 2000s that the discipline embraced again its teaching mission. Pedagogy sessions are repopulating the CAA annual conference and issues of *Art Journal* and *CAANews* have recently given over many pages to curriculum and assessment. Teaching is by no means a major focus of the discipline, but the conversation has been re-started.

This historical reluctance to speak about teaching practices has negatively impacted online art history in part because there has been no venue in which to talk about what might constitute a good online course. There was also no place to turn to read about best practices in online art history teaching. Already marginalized as adjuncts, as teachers rather than researchers, as junior faculty, as part of the commercialization of education, etc., the developers of online courses consequently toiled in solitude. Some, particularly those who benefited from the institutional support like that received by Dr. Allen and myself, stumbled onto good

solutions; others did not. But to point to the poorer e-learning courses and say, "I told you so!" fails to recognize the discipline's responsibility.

Both of us agree that developing online courses taught us more about pedagogy, curriculum, and assessment than we would have learned otherwise. Developing an e-learning art history course requires a critical self-consciousness rarely found in lecture courses. A good online course engages questions of how art history has displayed its teaching images; the histories and relative merits of teaching strategies; what learning outcomes we seek for programs; what types of examinations, activities, and assignments achieve these; how students learn, including their learning styles; and what technologies best suit the material and which ones are not appropriate for the discipline. As our individual essays reveal, online course development requires all of the types of activities that college and university academic plans and mission statements claim to seek: collaboration across campus, interdisciplinary dialog, outreach, and inclusion.

Online art history can possess all of the best qualities of the face-to-face experience but it must do so better than its bricks and mortar cognates to overcome the prejudices outlined here. It must apply learning outcomes rigorously, provide proof of its achievements regularly, and emphatically and generally be more pedagogically sound than face-to-face classes. The instructors must work hard to show their classes to the scholarly community, to conduct studies of the courses and publish them in peer-reviewed venues, and generally be the brightest members of their departments. College and university administrators must commit the funds needed to develop good classes and to reward faculty for this professional work, including valuing online course authorship during tenure deliberations. With aggressive promotion and smart work on all sides, online art history can gain ground it has been unfairly denied.

REFERENCES

Alberti, R. 1978. *Origine, et progesso dell'accademia del dissegno de' pittori, scultori, e architetti di roma.* Facsimile edition of the 1604 Pavia edition. Bologna: Arnaldo Forni Editore, Italica Gens Repertori di bio-bibliografia italiana, No. 96.

Alexander, B. 2006. Web 2.0: A new wave of innovation for teaching and learning. *EDUCAUSE Review* 41(2): 32-44.
http://educause.edu/ir/library/pdf/ERM0621.pdf.

Alley, L. and K. Jansak. 2001. Ten keys to quality assurance and assessment in online learning. *Journal of Interactive Instructional Development* 13(3): 3-18.

Ausubel, D., J.D. Novak, and H. Hanesian. 1978. *Educational psychology: A cognitive view* (2nd ed.). New York: Holt, Rinehart and Winston.

Bailey, C and M. Graham. 1999. Compare and contrast: The impact of digital image technology on art history. *Proceedings of the computers and the history of art conference.* Volume 2.
http://www.chart.ac.uk/chart1999/papers/bailey-graham.html.

Ball, S. 2005. CAA and pedagogy. *CAANews* 30(5): 2.

Bamford, A. n.d. The visual literacy white paper.
http://www.adobe.com/uk/education/pdf/adobe_visual_literacy_paper.pdf.

Barbour, W. et al. 2004. Integrating information literacy into the academic curriculum. *EDUCAUSE Research Bulletin* 18: 2-3.
http://educause.edu/ir/library/pdf/ERB0418.pdf.

Basseches, K. B. 2006. Artful teaching technologies: Redesigning an art education course to include Web-based strategies. Paper presented at the College Art Association Annual Conference, Boston, Massachusetts.

Beam, P. 1942-43. The color slide controversy. *College Art Journal* 2: 35-38.

Becker, L., and K. Schneider. 2004. Motivating students: Eight simple rules. Reprinted from *The Teaching Professor* 18(7): 5. Available from the Honolulu Community College Faculty Development Faculty Guidebook. Honolulu Community College.
http://honolulu.hawaii.edu/intranet/committees/FacDevCom/guidebk/te achtip/motiv8rules.htm.

Bellori, P. 1672. *Le vite de' pittori, sculptori ed architetti moderni.* Rome.

Benjamin, W. 1968. The work of art in the age of mechanical

reproduction. *Illuminations: Essays and reflections.* Ed. H. Arendt. New York: Harcourt Brace Jovanovich, 1968.

Bentkowska-Kafel, A., T. Cashen, and H. Gardiner, eds. 2005. *Digital art history: A subject in transition.* Bristol: Intellect Books.

Berenson, B. 1964. *The selected letters of Bernard Berenson.* Ed. A. McComb. Boston: Houghton Mifflin.

Bersson, R. 2005. Building the literature of art pedagogy. *CAANews* 30(5): 1, 3, 39-40.

Bransford, J. et al. 2000. *How people learn.* Commission on Behavioral and Social Sciences and Education, National Research Council. Committee on Developments in the Science of Learning. Washington, D.C.: National Academy Press.

Briggs, P. 1997. Teaching art history as distance education. *Teaching with Technology* (University of Wisconsin, Stout) 2(10). http://www.uwsa.edu/ttt/tttv2n10.htm.

Bruce, R. 1996. Digital photography: liquefier of museums? *Image* 39(3-4): 10-17.

Campeneau, M. 1996. Digital imaging and photography: Image manipulation and art history. *Computers and the History of Art* 6(2): 71-81.

Cañas, A. J., Carff, R., Hill, G., Carvalho, M., Arguedas, M., Eskridge, T., et al. 2005. Concept maps: Integrating knowledge and information visualization. In *Knowledge and information visualization: Searching for synergies.* Eds. S.-O. Tergan and T. Keller. Heidelberg and New York: Springer Lecture Notes in Computer Science.

Carlson, S. 2003. A leap from modesty to Cyberspace. *Chronicle of Higher Education* 50(15): A21.

Carnevale, D. 2007. Employers often distrust online degrees. *Chronicle of Higher Education* 53(18): A28.

Carpenter, J 1942-43. The limitations of color slides. *College Art Journal* 2: 38-40.

Carrier, D. and R. Cavalier. 1989. Theoretical and practical perspectives on technology and the history of art. *Leonardo* 22(2): 245-249.

Cason, N. 1998. Interactive multimedia: An alternative context for studying works of art. *Studies in Art Education* 39(4): 336-349.

Cavanaugh, J. and C. Cavanaugh. "Franchising higher education. *Chronicle of Higher Education* 52(33): B20.

Charp, S. 2000. Distance education. *Technological Horizons in Education Journal (THE)* 27(9): 10-12.

Churchill. D. 2005. Learning object: An interactive representation and a mediating tool in a learning activity. *Educational Media International* 42(4): 333-49.

Clancy, S. 2001. The cathedral as a virtual encyclopaedia: Reconstructing the "texts" of Chartres Cathedral. *Proceedings of the computers and the history of art conference.* Volume 4. http://www.chart.ac.uk/chart2001/papers/noframes/clancy.html.

Cock, M. 1997. Getting lost in a museum : An approach to multimedia in the gallery. *Proceedings of the computers and the history of art conference.* http://www.chart.ac.uk/chart97/cock.html.

Coe, B. 1978. *Colour photography.* London: Ash and Grant.

Cohen, K. 1997. The Niña, the Pinta, and the Internet. *Art Bulletin* 79(2): 187-191.

Cohen, K., J. Elkins, M. A. Lavin, N. Macko, G. Schwartz, S. L. Siegfried, and B. M. Stafford. 1997. Digital culture and the practice of art and art history. *Art Bulletin* 79(2): 187-216.

College Prowler. 2007. College Rankings. http://www.collegeprowler.com/find/guides-by-ranking.aspx?section=Computers

Collins, B.R., ed. 1995. Rethinking the introductory art history survey. *Art Journal* 54(3).

Conrad, R. and A. Donaldson. 2004. *Engaging the online learner: Activities and resources for creative instruction.* San Francisco: Jossey-Bass.

Costache, I. 1998. The work of art (historians) in the age of electronic (re)production. *Proceedings of the computers and the history of art conference.* http://www.chart.ac.uk/chart98/costache.html.

Coulter, B., C. Konold, and A. Feldman. 2000. Promoting reflective discussions: Making the most of online resources in your classroom. *ISTE Learning & Leading with Technology* 28(2): 44-49, 61.

DeBenedictis, E. 1995. Teaching with multimedia in the art history undergraduate classroom. *Computers and the History of Art* 5(1): 53-64.

Deleuze, G. 1977. *Dialogues.* Paris: Flammarion.

Derbentseva, N., F. Safayeni, F., and A.J. Cañas. 2007. Concept maps: Experiments on dynamic thinking. *Journal of Research in Science Teaching* 44(3): 448-465.

Donahue-Wallace, K., and J. Chanda. 2005. A case study in integrating the best practices of face-to-face art history and online teaching. *Interactive Multi-Media Electronic Journal of Computer Enhanced Learning,* 7(1). http://imej.wfu.edu/articles/2005/1/01/index.asp.

Drucker, P. 1999. Beyond the information revolution. *The Atlantic Monthly* 284(4): 47-57.

Duch, B., S. Groh, and D. Allen. 2001. *The power of problem-based learning: A practical how-to for teaching undergraduate courses in any discipline.* Sterling, V.A.: Stylus Publishing.

Elkins, J. 1995. Is it still possible to write a survey of art history? *Umeni* 43: 309-16.

—. 1996. *The object stares back: On the nature of seeing.* New York: A Harvest Book, Harcourt, Inc.

—. 1997. What are we seeing exactly? *Art Bulletin* 79(2): 191-98.

Elmendorf, D. 1895. *Lantern slides: How to make and color them.* New York: E & H. T. Anthony & Co.

Fawcett, T. 1983. Visual facts and the nineteenth-century art lecture. *Art History* 6(4): 442-60.

—. 1992. The nineteenth-century art book: Content, style and context. *Art Libraries Journal* 17: 12-17.

—. 1997. Art reproductions and authenticity. *Art Libraries Journal* 22: 20-25.

Félibien, A. 1668. *Conférences de l'Académie Royale de Peinture et de Sculpture.* Paris.

Foshay, W. 2002. Distance learning: Is that all there is, my friend? *Quarterly Review of Distance Education* 3(1): 65-74.

Freeman, C. 1990. Visual media in education: An informal history. *VisualResources* 6: 327-340.

Freitag, W. and B. Irvine. 1975. Slides. In *Nonprint media in academic libraries.* ACRL Publications in Librarianship 34. Ed. Pearce S. Grove. Chicago American Library Association.

Geser, J. 2007. Open educational practices and resources: The key role of the social software. *EDEN 2007 Annual Conference.* http://www.eden-online.org/eden.php.

Gibbons H., and G. Wentworth. 2001. Andragogical and pedagogical training differences for online instructors. *Online Journal of Distance Learning Administration,* 4(3). http://www.westga.edu/~distance/ojdla/fall43/gibbons_wentworth43.html.

—. 2002. Processes for motivating online learners from recruitment through degree completion. In *Motivating and retaining adult learners online.* Ed. V. Phillips. Essex Junction, VT: GetEducated.com. http://www.geteducated.com/articles/JournalMotivateRetain.PDF.

Gladwell, M. 2005. *Blink: The power of thinking without thinking.* New York: Little, Brown and Company.

Goldstein, C. 1996. *Teaching art: Academies and schools from Vasari to*

Albers. Cambridge and New York: Cambridge University Press.

Gordenker, E. 2002. Collaboration: Building a kiosk for digital responses. *Proceedings of the computers and the history of art conference.* Volume 5. http://www.chart.ac.uk/chart2002/papers/gordenker.html.

Greenhalgh, M. 2002. Learning from images over the Web. *Journal of the Association for History and Computing* 5(3). http://mcel.pacificu.edu/jahc/jahcv3/articles/greenhalgh/greenhalgh.html.

—. 2001. The classroom of the future. *Proceedings of the computers and the history of art conference.* Volume 4. http://www.chart.ac.uk/chart2001/papers/greenhalgh.html.

—. 2004. Art history. In *A companion to digital humanities*. Eds. Susan Schreibman, Ray Siemens, and John Unsworth. Malden, Massachusetts: Blackwell.

Grimm, H. 1897. Die Umgestaltung des Universitätsvorlesungen über neuere Kunstgeschichte durch die Anwendung des Skioptikons. *Beiträge zur deutschen Culturegeschichte*. Berlin.

Halsey-Dutton, B. 2002. Artifacts in Cyberspace: A model of implementing technology into art history education. *Art Education* 55(4): 19-24.

Hamilton, J. 1999. The virtual tutorial gallery: A dialogic approach to multimedia and art history education. *Computers and the History of Art* 8(2): 71-88.

Harvey, M. 1985. Ruskin and photography. *The Oxford Art Journal* 7: 25-33.

Hasluck, P. 1901. *An optical lantern and accessories: How to make and manage them, including instructions on making slides: With numerous engravings and diagrams.* New York: Funk and Wagnalls Company.

Hoffman, E.R. 2000. ARTIFACT: An interactive software program for the survey of art history. *Interactive learning: Vignettes of best practices from America's most wired campuses.* Ed. D. Brown, Boston, MA: Anker Publishing Co.

Hutchings, P., ed. 1998. *The course portfolio: How faculty can examine their teaching to advance practice and improve student learning.* Washington, DC: AAHE: The Teaching Initiatives.

Ivins, W. 1953. *Prints and visual communication.* Cambridge, Mass.: Harvard University Press.

Jenson, J. 2004. It's the Information Age, so where's the information: Why our students can't find it and what we can do to help. *College Teaching* 52(3): 107-112.

Jonassen, D. 2000. *Computers as mindtools for schools: Engaging critical thinking.* Upper Saddle River, N.J.: Merrill.

Karpinski, C. 1989. The print in thrall to its original: A historiographic perspective. In *Retaining the original: Multiple copies, copies, and reproductions*. Center for Advanced Study in the Visual Arts, Symposium Papers VI. Washington, D.C.: National Gallery of Art.

Keats, D. and P. Schmidt. 2007. The genesis and emergence of Education 3.0 in higher education and its potential for Africa. *First Monday* 12(3). http://firstmonday.org/issues/issue12_3/keats/index.html.

Knowlton, D. 2000. A theoretical framework for the online classroom: A defense and delineation of a student-centered pedagogy. In *Principles of effective teaching in the online classroom*. Ed. R. Weiss, D. Knowlton, and B. Speck. San Francisco: Jossey-Bass.

Kwastek, K. 2003. Visualising art history. *Proceedings of the computers and the history of art conference.* Volume 6. http://www.chart.ac.uk/chart2003/papers/kwastek.html.

Lagorio, C. 2007. The ultimate distance learning. *The New York Times.* January 7.

Lahav, S. 2001. An Introduction to Tate Modern. *Proceedings of the computers and the history of art conference.* Volume 4. http://www.chart.ac.uk/chart2001/papers/lahav.html.

Lakoff, G. and M. Johnson. 1980. *Metaphors we live by*. Chicago: University of Chicago Press.

Lambert, S. 1987. *The image multiplied: Five centuries of printed reproductions of paintings and drawings.* London: Trefoil Publications, 1987.

Lavin, M. 1997. Making computers work for the history of art. *Art Bulletin* 79(2): 198-201.

Layne. G. 1987. The Langenheims of Philadelphia. *History of Photography* 2: 39-52.

Leighton, H. 1984. The lantern slide and art history. *History of Photography* 8: 107-118.

Levy, R. 1997, Teaching the multimedia art historian. *Proceedings of the computers and the history of art conference.* http://www.chart.ac.uk/chart97/levy.html.

Lindner, Molly. 2006. Problem-based learning in the art-history survey course. *CAANews* 3:7-9.

Lowe, R. 2001. Understanding information presented by complex animated diagrams. In *Multimedia learning: Cognitive and instructional issues*. Eds. J. Rouet, J. Levonen and A. Biardeau. London: Elsevier Science.

Maddox, J. 1997. Web-based distance learning. Paper delivered at College Art Association Annual Meeting.

http://www.personal.psu.edu/faculty/j/x/jxm22/CAA/JMCAApaper.html

Mahon, D. 1947. *Studies in seicento art and theory*. London: Warburg Insitute, University of London.

Malraux, A. 1949-50. Museum without walls. In *The psychology of art*. New York: Pantheon Books.

Mayer, R. 1997. Multimedia learning: Are we asking the right questions? *Educational Psychologist* 32(1): 1-19.

Mehotra, C., C. Hollister, and L. McGahey. 2001. *Distance learning: Principles for effective design, delivery, and evaluation.* Thousand Oaks, CA: Sage Publications.

Mentkowski, M. 2000. Learning that lasts: Integrating learning, development, and performance in college and beyond. San Francisco: Jossey-Bass.

Minor, V. *Art history's history*. Englewood Cliffs, New York: Prentice-Hall/Abrams.

Mirzoeff, Nicholas. 1999. *An introduction to visual culture*. London and New York: Routledge.

Mokros, J., S. Russell, and K. Economopoulos. 1995. Beyond arithmetic: Changing mathematics in the elementary classroom. Englewood Cliffs, New Jersey: Dale Seymour Publications/Pearson Learning Group.

Moore, G., K. Winogard, and D. Lange. 2001. *You can teach online: Building a creative learning environment.* New York: McGraw Hill.

Nelson, R. 1997. The map of art history. *The Art Bulletin* 79(1): 28-40.

—. 2000. The slide lecture, or the work of art history in the age of mechanical reproduction. *Critical Inquiry* 26(3): 414-434.

Novak, J. 1998. *Learning, creating, and using knowledge: Concept maps as facilitative tools in schools and corporations.* Mahwah, NJ: Lawrence Erlbaum Associates.

Novak, J. and A. Cañas. 2006. The theory underlying concept maps and how to construct them. Technical report IHMC Cmap Tools 2006-01. Florida Institute for Human and Machine Cognition, http://cmap.ihmc.us/Publications/ResearchPapers/TheoryCmaps/Theor yUnderlyingConceptMaps.pdf.

Novak, J. and D. Gowin. 1984. *Learning how to learn.* New York, NY: Cambridge University Press.

Panofsky, E. 1968. *Idea, a concept in art theory*. Trans. Jospeh J. S. Peake. Columbia, S.C.: University of South Carolina Press.

Paivio, A. 1986. *Mental representations*. Oxford and New York: Oxford University Press.

Pevsner, N. 1940. *Academies of art, past and present.* Cambridge:

Cambridge University Press.

Phelan, Peggy. 2005. Art history survey: A round-table discussion. *Art Journal* 64(1): 34-35.

Pitt, S, C. Updike, and M. Guthrie. 2002. Integrating digital images into the art and art history curriculum. *Educause Quarterly* 2: 38-44.

Plato. 1956. *Phaedrus.* Trans. W.C. Helmbold and W.G. Rabinowitz. Indianapolis: Bobbs-Merrill Educational Press.

Pollini, J. 2005. Problematics of making ambiguity explicit in virtual reconstructions: A case study of the Mausoleum of Augustus. *Proceedings of the computers and the history of art conference.* Volume 8. http://www.chart.ac.uk/chart2005/papers/pollini.html.

Porter, L. 1997. *Creating the virtual classroom: Distance learning with the internet.* New York: Wiley Computer Publishing.

Promey, S. and M. Stewart. 1997. Digital art history: A new field for collaboration. *American Art* 11(2): 36-41.

Read, B. 2003. Art history without slides: digital images offer professors flexibility in teaching, but creating collections is difficult. *Chronicle of Higher Education* 49(20): A29.

Reynolds, J. 1975. *Discourses on art.* Ed. Robert R. Wark. New Haven and London: Yale University Press.

Rhyne, C. 1997. Student evaluation of the usefulness of computer images in art history and related disciplines. *Visual Resources* 13: 67-81.

Robinson, D. 1917. On reproductions for the college museum and art gallery. *Art Bulletin* 1: 15-21.

Rodda, J. 2005. An analysis of a lantern slide collection at the Institute of Fine Arts, New York University. *Visual Resource Association Bulletin* 32(3): 19-58.

Ruskin, J. 1903-1912. *The complete works of John Ruskin.* Ed. E.T. Cook and A. Wedderburn, 39 vols. London: George Allen.

Russo, T. 1995. A collaborative learning/assessment model. *Art Journal* 54(3): 82-3.

Saba, F. 2000. Shifting the focus from teaching to learning. *Distance Education Report* 4(13): 1-4.

Schmidt, M., W.H. Blackmon, D.R. Rehak, and D. Bajzek. 1999. Online art history: Design, development, and review of an interactive course. *Interactive Multimedia Electronic Journal of Computer-Enhanced Learning.* http://imej.wfu.edu/articles/1999/1/04/index.asp.

Schnotz, W. 2001. Sign systems, technologies, and the acquisition of knowledge. In *Multimedia learning: Cognitive and instructional issues.* Eds. J. Rouet, J. Levonen and A. Biardeau. London: Elsevier Science.

Schwartz, G. 1997. Digital imagery and user-defined art. *Art Bulletin* 79(2): 206-8.

Schwartz, P. 2001. *Problem based learning: Case studies, experience and practice.* New York: Routledge.

Sims, R. 1997. Interactivity: A forgotten art? *Computers in Human Behavior* 13(2): 157-80.

Sowell, J. 1991. Learning cycles in art history. *College Teaching* 39(1): 14-19.

Taylor, M. 2006. Sliding home. *Ancestry Daily News.* January 25, 2006, http://www.ancestry.com/learn/library/article.aspx?article=10897

University of North Texas. n.d. *UNT Historical Distributed Learning Graphs 2000-2007.* http://www.cdl.unt.edu/Content/About/Statistics/Historical_All_Charts _thru_Spring_2007.xls.

West Virginia Network (WVNET). Creating communities online. http://www.wvnet.edu/services/webct/building_communities.html.

Whisnant, W., J. Sullivan, J., and S. Slayton. 1992. The "old" new resource for education: Student age. *Community Service Catalyst* 22(3): 7-11.

Winckelmann, J. 1880. *The history of ancient art.* Trans. G. H. Lodge, 4 vols. in 2. Boston: James R. Osgood and Company.

Wölfflin, H. 1958. *The sense of form in art.* Trans. A. Muehsam and N. Shatan. New York: Chelsea Pub. Co.

Yang, Y. 2005. Preparing instructors for quality online instruction. *Online Journal of Distance Learning Administration,* 8(1). http://www.westga.edu/~distance/ojdla/spring81/yang81.htm.

Young, J. 2002. Ever so slowly, colleges start to count work with technology in tenure decisions. *Chronicle of Higher Education* 48(24): A25.

Zimmerman, M., ed. 2002. Introduction. In *The art historian: National traditions and institutional practices.* Williamstown, MA: Sterling and Francine Clark Art Institute.

Zull, J. 2002. *The art of changing the brain: Enriching the practice of teaching by exploring the biology of learning.* Sterling, V.A.: Stylus Publishing.

LIST OF CONTRIBUTORS

Eva J. Allen is Collegiate Associate Professor of Art History at the University of Maryland University College.

Stephen Carroll is a Lecturer in the English Department of Santa Clara University.

Robert Carlucci is the Manager of Visual Resources in the Sterling Memorial Library at Yale University.

Christine Cavalier is a Photographer and Digital Media Specialist at Tufts University.

Kelly Donahue-Wallace is Associate Professor of Art History and Chair of the Department of Art Education and Art History at the University of North Texas.

Beth Harris is Director of Distance Learning at the Fashion Institute of Technology.

Alexander Haubold is a doctoral student in the Computer Science Department at Columbia University.

Eva R. Hoffman is Associate Professor of Art History at Tufts University.

Laetitia La Follette is Associate Professor of Art History at the University of Massachusetts Amherst.

Dolores laGuardia is a Lecturer in the English Department at Santa Clara University.

Andrea Pappas is Associate Professor in the Department of Art and Art History at Santa Clara University.

Geoffrey Simmins is Professor in the Department of Art at the University of Calgary.

Jeremy Stynes is a User Experience Strategist at ARTstor.

Christopher L. C. E. Witcombe is Professor in the Department of Art History at Sweet Briar College.

Steven Zucker is Dean of Graduate Studies at the Fashion Institute of Technology.

INDEX

Note: The letter *f* following a page number denotes a figure.

Association of Art Historians, 5

Bailey, C., 10
Ball, S., 136
Ballon, H., 68n11
Barbour, W., 106
Becker, L., 120
Bellori, G. P., 17
Benjamin, W., 35, 36
Bentkowska-Kafel, A., 80
Bersson, R., 9
blended-learning, 69–70, 127
blending vs. radical change in
 teaching art history, 11, 44–56
Blink (Gladwell), 107
blogs, 26, 39, 130, 131, 133
Bransford, J. D., 6n7, 70
Braun, A., 18
Briggs, P., 10, 111
Brown, A. L., 6n7
"Building the literature of art
 pedagogy" (Bersson), 9

CAANews, 9, 10, 136
Carlucci, R., digital image
 collections essay by, 6n6, 11–
 12, 57–68
Carnevale, D., 136
Carroll, S.
 course management software and
 collaborative teaching essay
 by, 12, 69–78
 implementation and application of
 computer-mediated
 technology essay by, 11, 23–
 32
Cashen, T., 80
Cason, N., 10, 110
Chanda, J., 10, 113
Charp, S., 121
Chickering, A. W., 6n7
Churchill, D., 111n4, 112
Clancy, S., 10
Cock, M., 10
Cocking, R., 6n7
Cohen, K., 79, 80

Cohen, S., 83n3
collaborative student project, 102,
 103, 104–5, 108
collaborative teaching project
 assessment and outcomes of, 76–
 78
 course management software, and
 process for, 12, 73–76
 design for, 71–73, 73n4
 goals for, 69–71, 71n1
 process of, 73–76
 recommendations for instructors
 in, 77
College Art Association, 5, 9–10,
 79n1
College Prowler, 27
Collins, B. R., 10n9, 79
Columbia University, 11, 57–68
computer-assisted concept maps
 described, 82–83
 global history of art examples of,
 84–86, 86f–96f
 for survey courses, 12, 79–96,
 86f–96f
 See also ARTIFACT (computer-
 assisted concept maps)
computer-mediated instruction
 art history courses using, 6–7
 implementation and application
 essay on, 11, 23–32
 interactive exercises in, 6, 6n7,
 126–27
 See also teaching art history;
 specific technologies
computers, use of, 5–7, 10–11
Computers and the History of Art
 (association), 5
concept mapping. *See* computer-
 assisted concept maps
Costache, I., 10
Coulter, B., 121

Daguerre, L., 19
Daguerreotype photographs, 19–20
DeBenedictis, E., 110
Deleuze, G., 57

audio files and, 133
online courses, and integration
with, 7, 8, 67, 106, 106n6, 125
supplemental information from
websites for, 101, 104, 118,
125, 132
MySpace, 37, 132

Nelson, R.
on art history survey courses, 79,
80
on digital technology, 80, 81
on effect of slide lecturers, 9, 36n1
on performative triangle, 111, 125
new media and new technology, 1n1
See also digital technology

The Object Stares Back (Elkins),
107
OER (open educational resources),
132–33
See also intellectual property
rights
online courses
assessment of student learning in,
76–78, 108, 113, 118
blended-learning in, 69–70, 127
class scenarios for, 104–5
collaborative student project in,
102, 103, 104–5, 108
critical inquiry in, 121
current state and future of, 12, 52–
53, 130–37
delivery of, 100–103, 100n4, 101f,
102f
described, 7
design and redesign for, 48–49,
49–50nn10–13, 51–52, 51f,
53–56, 54f–56f, 128–29
development of, 12, 98–100, 110,
110n2, 114–15, 114n6, 137
digital technology for, 111–13,
112f, 122–25
discussions in, 122–23, 123f,
123n3
education success in, 135

faculty for, 1, 2, 134, 135–36
funds for, 100, 110, 137
implementation of, 110, 110n2,
114–18, 116f, 117f
information literacy and, 106–7
instructor-driven, 12, 109–13,
112f
intellectual property rights for
materials in, 4, 4n4, 100, 110
learning styles of students in, 120–
21
motivating participation in, 12,
119–20, 120nn1–2
multiculturalism, and integration
with, 105
multimedia resources for, 130–32,
131n2
museum visits, and integration
with, 106, 106n6
participation by students in, 127–
28
problems and solutions in, 105–8,
106n6
retention of information in, 105
status of, 136, 137
student-driven, 12, 112–18, 121
trends in, 12, 130–34
undervaluation of, 134–35
visual literacy and, 9, 107, 111,
117, 125
See also survey courses
open educational resources (OER),
132–33
See also intellectual property
rights

Paivio, A., 111
Panofsky, E., 19
Pappas, A.
on course management software
and collaborative teaching, 12,
72, 74–77
course management software and
collaborative teaching essay
by, 12, 69–78

156

visual culture, field of, 15
visual literacy, 9, 107, 111, 117, 125
Visual Media Center (VMC), 57n1,
 58–60, 65, 66, 68
*Le vite de' pittori, sculptori e
 architetti moderni...* (Lives)
 (Bellori), 17
VUE (Visual Understanding
 Environment), 83–84, 83–84n4

Wentworth, G., 120, 121
Westermanns, M., 68n11
Whisnant, W., 121
wikis, 26, 39, 130, 131, 133
Winckelmann, J., 19
Witcombe, C.
 Art History and Technology, 16
 digital technology defined by, 1n1,
 16

use of various technologies in
 teaching essay by, 5, 5n5, 11,
 14–22
Wölfflin, H., 18
World Wide Web, 15, 21
writing, invention of, 23–25
writing composition, 69–70
 See also collaborative teaching
 project

Yang, Y., 126, 127
Young, J., 136

Zimmerman, M., 108
Zuccaro, F., 17
Zucker, S., 5n5, 11, 33–43, 131
Zull, J., 70